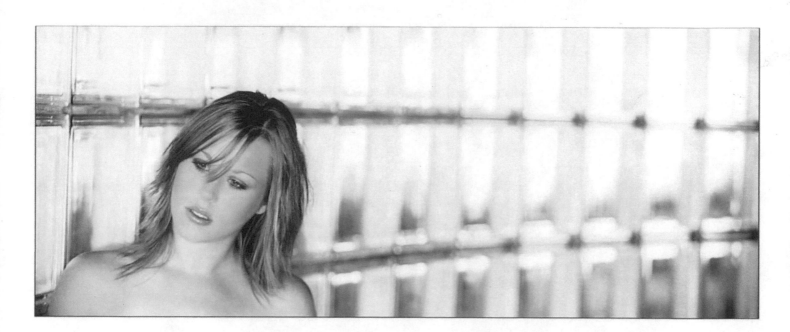

100
WAYS TO TAKE BETTER
PORTRAIT
PHOTOGRAPHS
DANIEL LEZANO & BJORN THOMASSEN

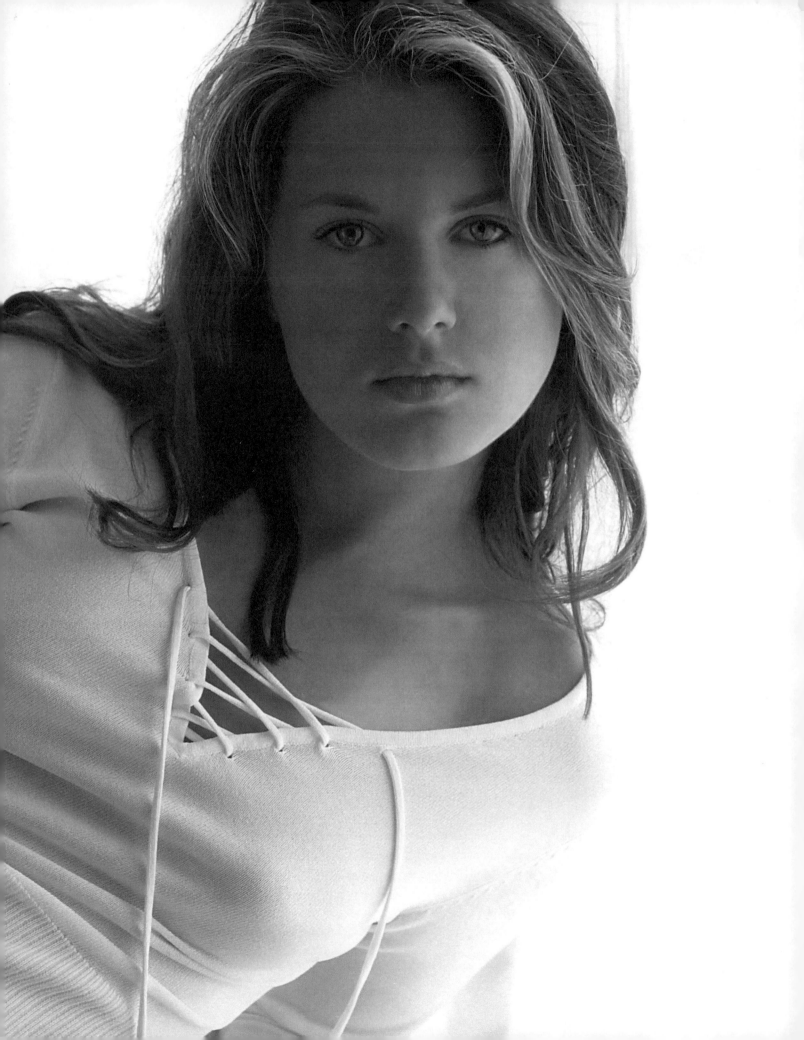

100
WAYS TO TAKE BETTER
PORTRAIT
PHOTOGRAPHS
DANIEL LEZANO & BJORN THOMASSEN

D&C
David and Charles

To all my family, especially Jo and Ellie.
Both are my inspiration.
Daniel Lezano

To the sweetest young person in the whole
world, my son Keian and to all of my family
whom I love so dearly.
Bjorn Thomassen

acknowledgments

Producing a book like this requires the cooperation of many, and
my thanks go to everyone who helped Bjorn and me put it together.
I would like to thank my family for their support (in particular my
partner Jo who must have wondered when I would return to
normal life), my daughter Ellie and her friend Ruby for being such
wonderful child subjects, and the various professional models we
worked with, in particular Charlie and Vanessa. Finally, many thanks
to Canon UK for providing a superb range of digital SLRs and lenses
to shoot with, The Flash Centre in London for the use of their superb
Elinchrom studio flash outfits, Lastolite for their reflectors and diffusers
and Manfrotto for their support.
Daniel Lezano

Well, Dan has said it all really, but I would like to reiterate a special
thank you to Chris Whittle of Elinchrom and all the wonderful staff at
The Flash Centre, the great people at Canon UK, especially Angela,
Ashley and Hayley for their continued support, Charlotte Thomson for
her contributions as a model and a PA, and all of the models without
whom this book would not have been possible.
Bjorn Thomassen

contents

Introduction

Over the years I have tried just about every branch of photography, from product shots of three-piece suites to landscape and even aerial photography. However, my natural passion for people has driven me to specialize in portraiture. I enjoy all aspects of portrait photography, almost without exception, from capturing the endearing first smiles of a baby to the challenges of a more formally composed corporate portrait. I even enjoy covering weddings, with all the pressure of highly charged emotions and limited time that they bring.

I believe that to be a good portrait photographer, you must be in touch with your feelings and emotions. It is vital that you are able to form a relationship with your subject so that they feel comfortable with you taking pictures of them. If the atmosphere in the session is stiff and awkward, your subjects will communicate this in their pose and expression, and there is no chance that you will get the sort of warm and relaxed portraits you're after. I sometimes feel that the success of a session ultimately has more to do with interpersonal skills and psychology than it does with technical know-how.

That is not to say that you don't need technique though, and, as with all genres of photography, light is everything. Early in my studies I learnt that expanding my knowledge of lighting enabled me to tackle portraits, even in the most difficult situations, with a greater degree of confidence. My consequent study of light has led to a fascination that still consumes me today. I am constantly in awe of the lighting masters, and still hungry for knowledge. I believe that you could study lighting for a lifetime and still run out of time.

This book covers a diverse range of styles, techniques, ideas and tips, the majority of which do not involve complex or expensive equipment and are therefore within the reach of any keen photographer. I hope that this will provide some enlightenment and inspiration and help you take better portraits. I wish you every success with your portraiture.

Bjorn Thomassen
bjorn-vision@btconnect.com

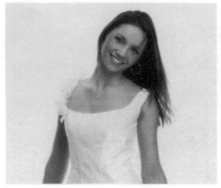

Photography dominates my life, both at home and at work. When I'm not writing about it, I'm reading about it or – best of all – taking pictures. Although I am keen on all types of photography, I am most passionate about portraiture. I certainly get a buzz from shooting landscapes, still lifes and other subjects, but nothing comes close to the excitement and enjoyment of taking portraits. Why? Well, among other things, it's great to receive a positive reaction from the subjects themselves, and satisfying to capture a moment in somebody's life. Above all though, I find people incredibly interesting. I am a naturally gregarious person, and although I enjoy the solitude that comes with shooting scenics or nature, I far prefer interacting with other people.

I also think that portraiture is a challenging and stimulating form of photography. There is far more to taking a portrait than simply pointing the camera at your subject and pressing the shutter. A good portrait reveals something of the subject's character, whether it's a mood, a hint of humour, or some other aspect of their personality or lifestyle. The skill to revealing this is in how you interact with the subject; if you can gain their trust and put them at ease, you're halfway there.

Although equipment is important, don't be fooled into thinking you need expensive gear. Most of the techniques covered in this book were purposely selected to be achievable with modest equipment. Whether you use film or digital, you will find the majority of these images within your grasp. Finally, with image manipulation now an accepted part of the picture-forming process, we have also covered some useful Photoshop techniques to help polish up your images.

I hope that you will find this book interesting, inspiring, and a useful aid to improving your portrait photography. If you do, and you would like some further advice and practical experience, then join Bjorn and me on one of our photo workshops, which we hold in the UK and USA. It would be great to meet you. If you have any queries, feel free to email me and I will try to help.

All the best with your portrait photography!

Daniel Lezano
m a i l @ l e z a n o . c o m

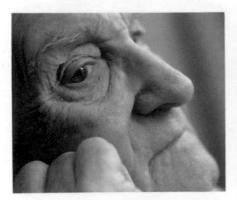 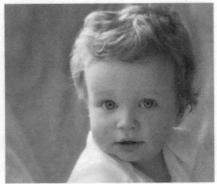

Equipment for portraits

Although it is true that portraits can be taken using virtually any type of camera outfit, there are some that are particularly suited to the genre. You will find below our broad recommendations as to what we think are the best choices. We have assumed that you are like the majority of enthusiast photographers in that you are working to a budget. Therefore, we have chosen items that, as far as possible, are within the budgets of most people.

Before getting down to specifics, it is worth pointing out that we have centred our choices around digital cameras. That is not because we are anti-film; it is simply because sales of film cameras have been in massive decline in recent years and this trend is accelerating. Therefore, if you are considering buying new equipment, we would recommend that you opt for a digital outfit, which, compared to film, offers similar quality and numerous advantages, including instant review, easier post-production and reusable media.

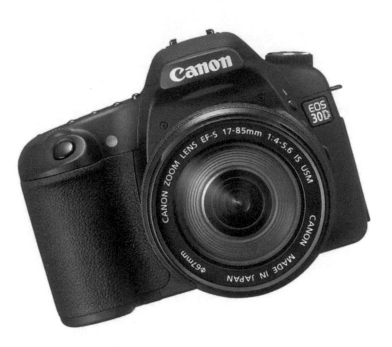

Cameras

A digital SLR (DSLR) offers by far the best mix of versatility, quality and affordability. Even entry-level models offer resolutions ranging between 6 and 8 million pixels – more than good enough for 12x8in prints. Add to this an excellent range of features, such as multi-point autofocus, sophisticated metering patterns, integral flash and interchangeable lenses, and you have a camera that is both very capable and excellent value for money. Models such as the Canon EOS 30D are superb value, offering 8 megapixels, 35-zone evaluative metering and access to a huge system of lenses, flashguns and accessories.

Lens choice

Ideally, you should own a lens that covers a focal length of around 85mm (in 35mm terms), so the standard zoom that is supplied with a DSLR kit is suitable. You might also want to consider a telephoto zoom, as this offers extra creative possibilities, including candid photography. The other alternative is an ultra-wide-angle zoom. This can be used for unusual compositions as well as when you want to include much of the scene in the frame – for example, when taking environmental portraits.

Studio flash kits

While daylight offers a wealth of lighting options, studio flash cannot be matched for its level of control. A single flash head kit is adequate to begin with, but you should try to stretch to a two-head outfit. Budget kits are a good place to start, but invest a little more if you can, as more expensive heads offer more power, variable ratio control and faster recycling. Various brands are available; we would recommend Prolinca and Elinchrom, as they offer excellent performance and reliability. Most come supplied with a silver or white brolly, but it is a good idea to buy a softbox attachment as well.

Lens focal length

Because most DSLRs have a sensor that is smaller than a 35mm film frame (APS-C sensor), you usually need to multiply the stated focal length of the lens by a given ratio to find its 35mm equivalent. For instance, the sensor of most consumer DSLRs effectively requires you to multiply the lens's stated focal length by 1.5x to find out how it equates to 35mm photography.

This is important, because lenses that are designed for DSLRs generally have a wider focal length than those made for film cameras. Let's take standard zooms, for example. An 18–55mm 'digital' lens is equivalent to around 27–82mm (this is 18–55mm multiplied by 1.5x) in 35mm terms, while fitting a 28–80mm zoom lens designed for film cameras effectively becomes a 42–120mm zoom when used on a DSLR. The table below gives an indication of the effective focal length of a lens fitted on a consumer DSLR with an APS-C sensor.

Accessories

There are a number of accessories that a portrait photographer should consider essential. Reflectors are one; these are an inexpensive aid for controlling light. While useful in the studio, they are invaluable when used outdoors in daylight. The same can be said for diffusers, which can be used to produce flattering light in the harshest of conditions. Lastolite make an incredible range of reflectors and diffusers to suit all lighting situations, and come highly recommended.

Finally, despite the accuracy of a camera's metering system, you cannot beat a good-quality light meter for taking perfect exposures. Buy a combined meter, which reads daylight and flash exposures. We both use Sekonic meters as they are very accurate and consistent.

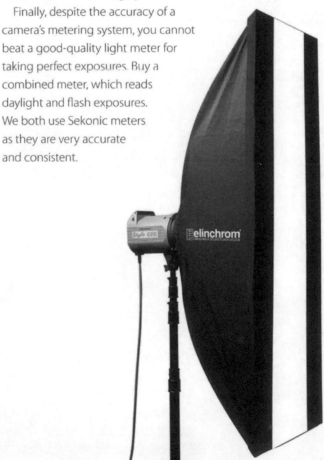

Stated focal length	Effective focal length (35mm equivalent)
'DIGITAL' LENSES	
11–18mm	16–27mm
18–55mm	27–82mm
18–125mm	27–187mm
55–200mm	82–300mm
TRADITIONAL 'FILM' LENSES	
17–35mm	25–52mm
28–80mm	42–120mm
70–200mm	105–300mm
100–300mm	150–450mm

Portrait Basics

If you are taking your first steps in portraiture, following the techniques set out in this section will help you master the basic skills required to take great pictures.

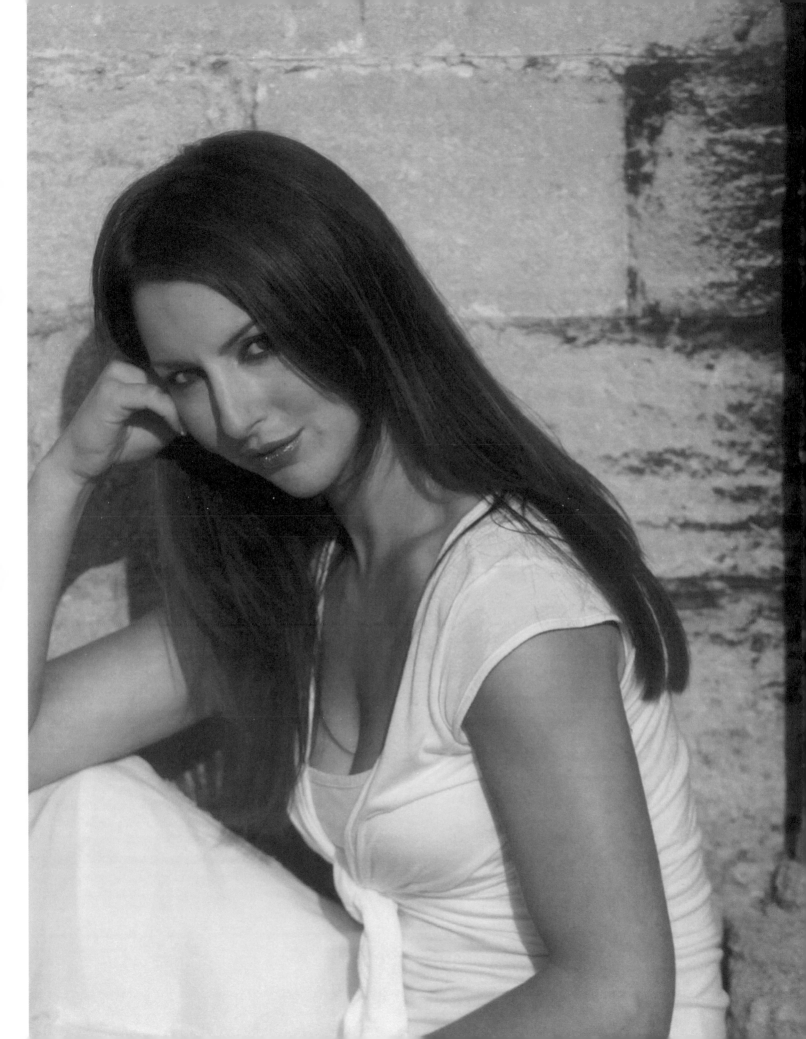

1 Keep it simple

As you will discover as you read through this book, there are any number of techniques that you can try when you are shooting portraits. The one thing to remember at all times is not to overelaborate when keeping it simple will work just as well. Keep the lighting as straightforward as possible, have your subject feel as natural and relaxed as they can, choose the right equipment for the job and you are well on your way to capturing fantastic portraits.

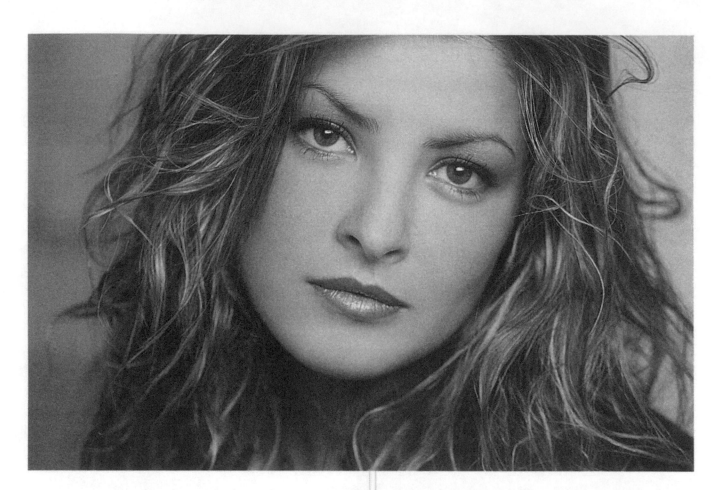

DANIELLE

This is a very striking and powerful portrait despite its simplicity. The subject has adopted a pleasing and still expression, but has introduced energy by tilting her head. Diagonals are a great way of bringing movement and flow to an otherwise static image. Preparation before the picture is taken is very important, and the model's make-up and careful hair styling has added a fashion appeal to this shot. Lighting is from a single studio flash head fitted with a strip light; a similar effect could be created simply with windowlight.

Canon EOS-1DS, 70–200mm at 200mm, 1/125 sec at f/5.6, ISO 100.

Focus on the eyes

Regardless of whether you are shooting landscapes, wildlife or portraits, finding a strong focal point in your pictures is a basic requirement if your image is to have any chance of success. With portraiture, this is normally achieved by ensuring your subject provides strong eye contact by looking directly into the lens.

Direct eye contact is an important aspect of everyday communication between people and so, while strong eye contact is not always essential in your images, it is a relatively simple way of ensuring the viewer is engaged by your subject and their attention held.

You can emphasize the eyes in a number of ways. Using mascara and other eye make-up is one method, while having the subject face the camera directly, so that both eyes are equally sized and prominent, is another. You should ensure that your lens focuses directly on the eye, and not on another part of the face, or the eyes may appear slightly unsharp. This is especially true if you are using a wide aperture, as this gives a shallow depth of field. If you have multi-point autofocus on your camera, a good method is to engage the central point only, focus lock the autofocus on the eye and recompose the frame before fully depressing the shutter button.

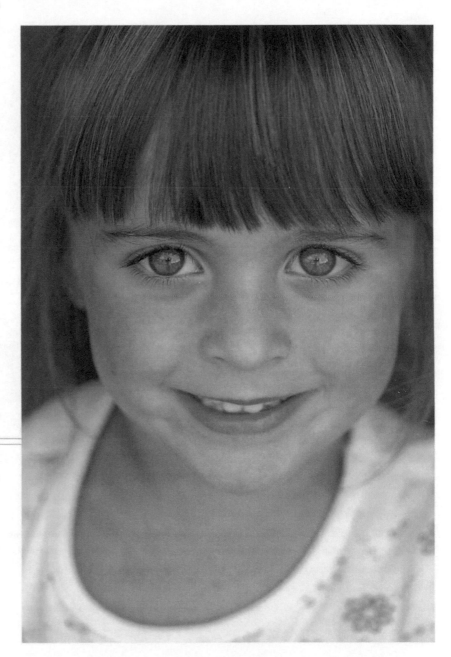

EYE TO EYE CONTACT

Your view is instantly drawn to this little girl's eyes as soon as you look at the image. The eyes were given extra emphasis by shooting from a slightly higher viewpoint and by using the short end of a telephoto zoom to tightly crop her face. Shooting at the lens's maximum aperture threw much of her face out of focus, so careful focusing was required to keep both eyes sharp.

Canon EOS 300D, 70–200mm f/2.8 zoom lens, 1/160 sec at f/2.8, ISO 100.

3 Choose the best lens for portraits

It is generally accepted that the best lens for portraiture is one that offers a short telephoto setting of between 50mm and 135mm. This focal length produces a very flattering perspective and allows you to shoot from a good working distance. This means a standard zoom (e.g., a 28–80mm) is suitable at its tele end; the short end of a telephoto zoom (e.g., a 70–210mm) is also good. Wide-angle lenses are not the best choice for general portraiture, as they exaggerate perspective – they can make noses look overly large, as well as shrinking ears. While most zooms are suitable for portraits, you should also consider prime lenses such as 85mm or 135mm. These lenses are designed primarily for portraits and offer very sharp optics as well as a fast maximum aperture; this is useful when you want to throw the background out of focus.

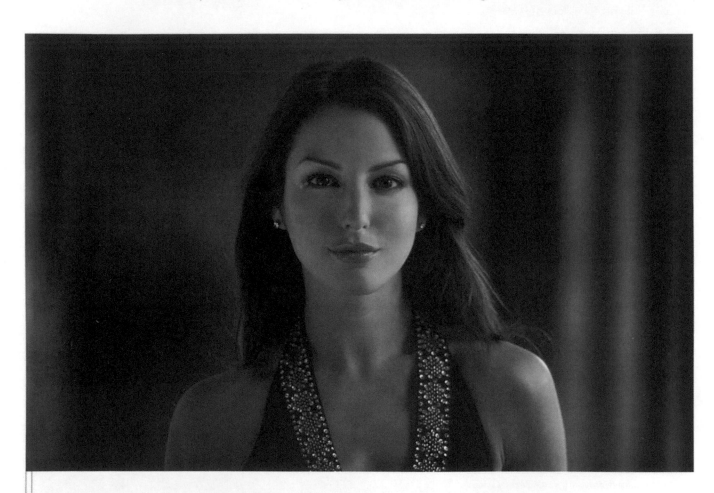

PERFECT PORTRAIT

This very simple composition illustrates all the advantages of shooting with a fast lens at the optimum portrait focal length. The subject's features appear to their greatest advantage and, by selecting the maximum aperture, the background is thrown totally out of focus. Cheaper lenses usually deliver their worst optical performance at their widest aperture setting, but a pro-spec Canon zoom ensured the optics delivered a sharp result at f/2.8. Canon EOS-1DS, 70–200mm f/2.8 lens at 135mm, 1/200 sec at f/2.8, ISO 400.

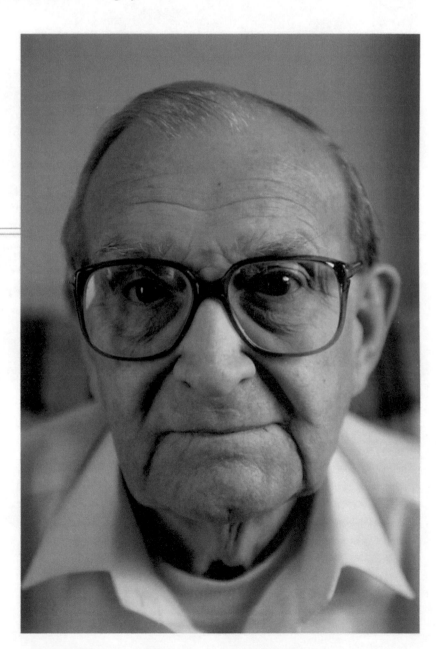

Choose the most effective viewpoint

One of the most important aspects when shooting portraits is deciding what viewpoint to take. Whether you shoot at eye level with your subject, slightly above it, or slightly below can have a major impact on the final image. There is no right or wrong answer, as much depends on the shape of your subject's face and features and on your individual style of photography. You should experiment from different heights and angles to see which best flatters the subject. For instance, if your subject has a long nose, shooting from above will accentuate it – shooting from lower down will give a more flattering result. Conversely, if your subject has a double chin, a lower viewpoint is the worst option, while shooting from higher up will tighten the skin. Viewpoint can also have a subtle effect on how the subject appears – looking up can make them appear submissive; looking down can make them seem dominant or even haughty.

FACE TO FACE

Many photographers have a preference on viewpoint, and ours is to shoot from slightly above eye level. We find this gives a pleasing perspective and usually results in the most flattering outcome. Having your subject tilt their head up to look at you helps tighten their skin, which is useful if they are a little overweight or elderly. In this example, the subject was sitting near a window, and having him tilt his head helped to minimize the reflections in the lenses of his spectacles.
Canon EOS-1DS Mark II, 28–70mm f/2.8 lens, 1/100 sec at f/2.8, ISO 320.

5 Match props to the scene

Everything that is contained within the frame is important and can convey meaning in your portrait, so pay close attention to the background and props that you include in the scene. This can be particularly effective if you want to boost the drama of your portraits and create a particular mood or a stylized theme for a shoot. Choose a setting, clothing and jewellery to suit this. In a picture like this you are creating a fiction, so all the elements must work harmoniously together to portray the theme successfully. You will also need to think carefully about your model and make sure that she or he looks right for the part and is comfortable projecting the mood you wish to communicate.

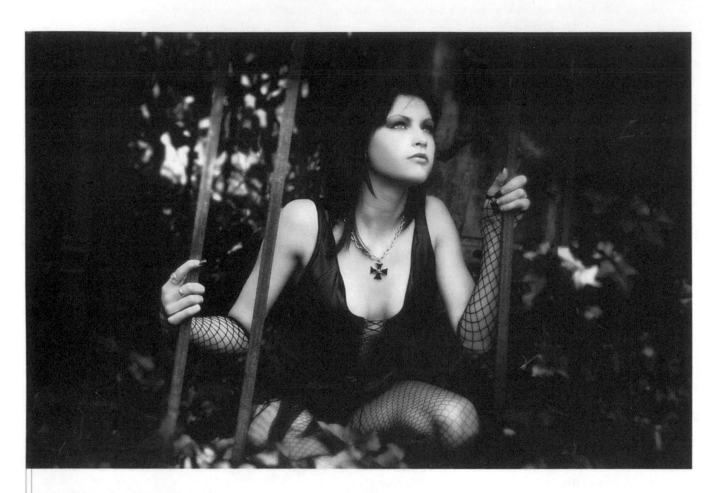

JADE IN GOTHIC STYLE
This image has a strong gothic theme that required appropriate styling for the model and a suitable location – a churchyard. The subject wore appropriately themed clothing and make-up. Her necklace and artificial fingernails add to the effect and illustrate how simple and inexpensive accessories can create a strong style.
Canon EOS-1DS, 28–70mm at 70mm, 1/125 sec at f/4, ISO 400.

Use bold colours

Although much portrait photography involves working with the subject to get the best from them, there are instances when both the subject and their surroundings are equally important in an image. Be aware of the potential a backdrop offers and how you might use it to add an extra element to the picture. Exploiting a boldly coloured background is a particularly effective way to add impact to a scene. However, you need to make the subject and the surroundings work together. In a scene with very dominant colours, the people in the frame may easily be overpowered and overlooked, so you need to make them noticeable. First, ensure that they are not too small in the frame – they should fill at least a third of the image. Second, ensure they are dressed in equally vibrant colours so that they stand out. This often calls for careful colour coordination – look for colours and tones where the subject contrasts with the background so that each draws attention without gaining complete dominance of the image.

You may find that a composition made up of only two strong colours can work as well as a scene with three, four or more colours. There is no strict rule on the optimum number of colours to use, although using too many may result in a visual mess. Experiment to find which colour combinations work well together.

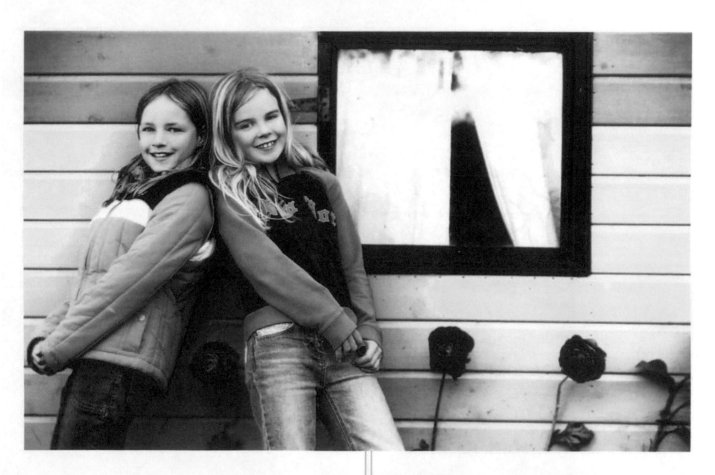

VIBRANT BACKGROUND

This is a gloriously vibrant and lively image. The colours of the scene are full of energy and are matched by the strong smiles and colours of the girls' clothing. The colours in the image were boosted further by tweaking Curves in Photoshop to increase contrast and give the image a cross-processed look, where the colours take a departure from reality. The increased contrast made the background dominate the scene, so Gaussian Blur was used to soften it slightly.

Canon EOS-1DS, 70–200mm at 100mm, 1/200 sec at f/4, ISO 400.

7 Reveal a subject's hobby

Portraits should try to reveal something of the sitter's personality, or give clues to their hobbies and interests. Giving a viewer visual clues is the easiest way to do this, and you can be as understated or as blatant as you wish. One effective method for representing this is to include clothing or items that are associated with the subject's interests in the frame. Depending on the style of the image, make these elements as bold and graphic as you like, or instead place subtle clues to force the viewer to discover a hidden secret.

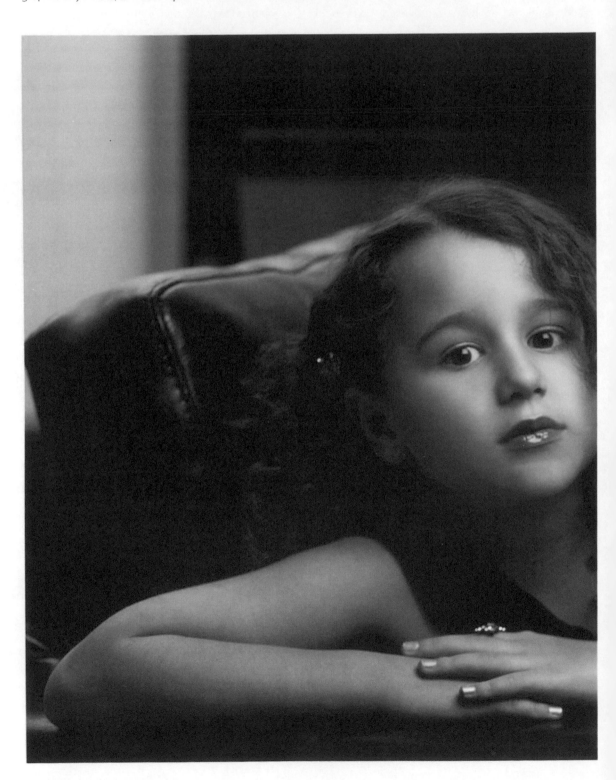

STELLA

This is a very traditional portrait in terms of pose and lighting, with a well-structured pose and a relatively simple lighting set-up (one softbox and one reflector). The sitter is a very keen pianist, which is revealed by placing the piano in the background, but throwing it out of focus so as not to be distracting but still be identifiable. The clothing was kept suitably formal and the colours matched to keep all the tones even throughout the frame.
Canon EOS-1DS, 28-70mm at 50mm,
1/200 sec at f/4, ISO 400

8 Prepare for candid shots

Candid photographs are, by their very nature, a spontaneous form of portraiture but can be the simplest and most effective way to capture your subject. With no preparation possible, the results can never be properly predetermined or controlled. However, if you want to shoot candid portraits successfully, then you need to be ready to take advantage of that split-second moment when the perfect image presents itself.

If you are taking pictures of someone you don't know, it is important that they don't see you – once they spot you, you may as well give up. So, use a long telezoom, such as a 70–300mm, and keep your distance. Study your subject first without attempting to photograph them. Watch how they behave and see if they have any habits. Busy places like markets are ideal locations, as you will be inconspicuous in the crowd. Have your camera and lens set to the appropriate settings so you are ready to work fast. Watch, wait and, when the moment presents itself, raise the camera, take a quick frame or two, then lower the camera before you draw attention to yourself. With people you know, you may need a different approach, as they are probably more aware that you will be taking their picture. The secret is to spend a bit of time with them so that they forget you have a camera with you. Once they are relaxed and comfortable, be ready to fire off a few frames.

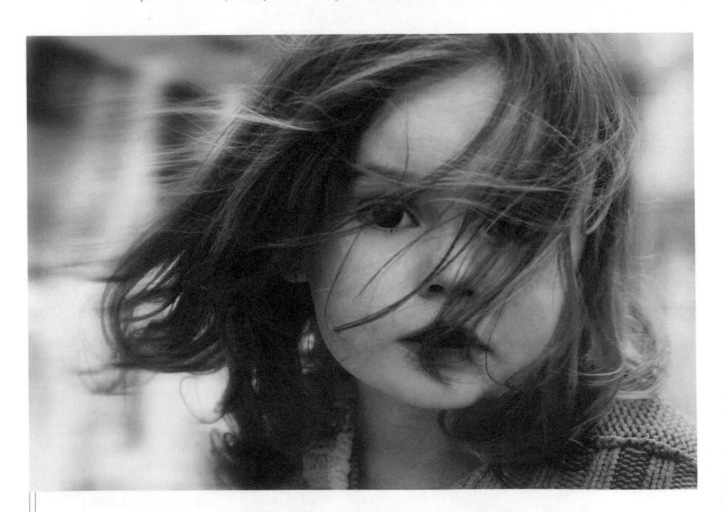

ELLIE
The best way to capture candid shots is when your subject is distracted. In this instance, the child was busy feeding bread to some ducks, which allowed the photographer to prepare for the shot. When everything was ready, the child's name was called and the shutter was fired as she looked round.
Nikon D70S, 18–70mm at 70mm, 1/500 sec at f/4.5, ISO 200.

Watch the hands

Where would we be without our hands? As we all learned at school, it is the dexterity of our fingers and opposable thumbs that led to humanity's emergence as the dominant species on the planet. We owe much to our hands, so let's not forget them in our images. Unfortunately, hands are not always the prettiest subjects to photograph and in portraiture it's always worth paying close attention to how they are posed. Try to get your subject to make an elegant shape with a slightly curved hand. A flat hand rarely looks good, especially if positioned full-on to the camera. Hands can also make interesting subjects in themselves: manicured hands might be more aesthetically pleasing, but old, gnarled hands have their own character and can make for interesting images. You can emphasize hands in an image by shooting close-up crops of them so that they fill the frame, or by shooting a wide-angle shot with hands prominently in the foreground.

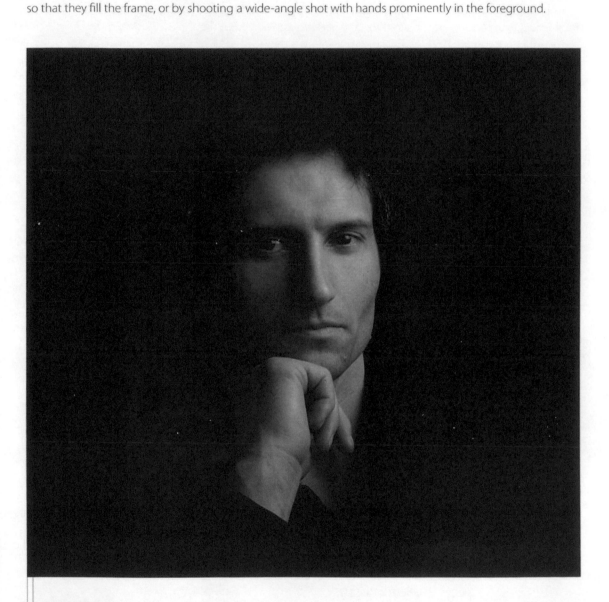

COMMANDING

The aim here was to produce a portrait that gave the subject a strong and commanding look. Shooting with a single flash head allowed for directional lighting, which works well with this subject's features to give him a strong look. Having him rest his chin on his relaxed fist gives the image additional interest and alters the viewer's perception of the subject, giving him a thoughtful and pensive air that would have been missing if the hand had not been included in the frame.
Canon EOS 10D, 28–70mm f/2.8 lens at 60mm, 1/125 sec at f/8, ISO 100.

10 Blur the background

To ensure your main subject has maximum emphasis, while everything else – in particular the background – is as unobtrusive as possible, is one of the most basic goals of a good portrait. This can be done by controlling the depth of field with the lens aperture you select. The simplest way to do this is to shoot in aperture priority autoexposure and select a wide aperture. However, sometimes this is not enough – although a telephoto lens has a very shallow depth of field at relatively wide apertures, such as f/5.6, with a wide-angle lens even this setting can sometimes result in a relatively sharp background. Whenever possible, shoot at the widest aperture setting to minimize the depth of field.

With busy backgrounds, you may occasionally find that Photoshop's Blur tool can be used to throw the background even further out of focus. This can be a tricky technique to apply, however – the most effective and easiest method is to achieve the effect at the time of shooting.

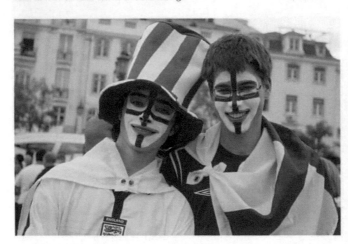

FOOTBALL FANS

This portrait of two colourful football fans was captured with the lens at maximum aperture to throw the background out of focus as much as possible. However, even at f/4, the buildings in the background are still sharp enough to be relatively distracting. For this reason, the background was further blurred in Photoshop by using the Lasso tool to isolate the figures and then using the Blur tool to defocus the background.
Canon EOS-1D Mark II, 17–40mm f/4 lens, 1/640 sec at f/4, ISO 125.

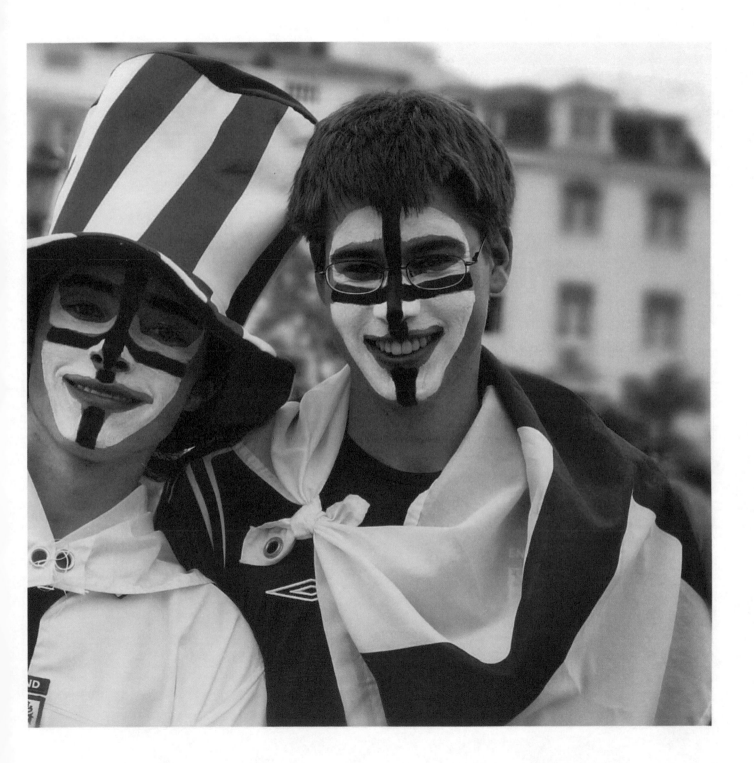

Composition

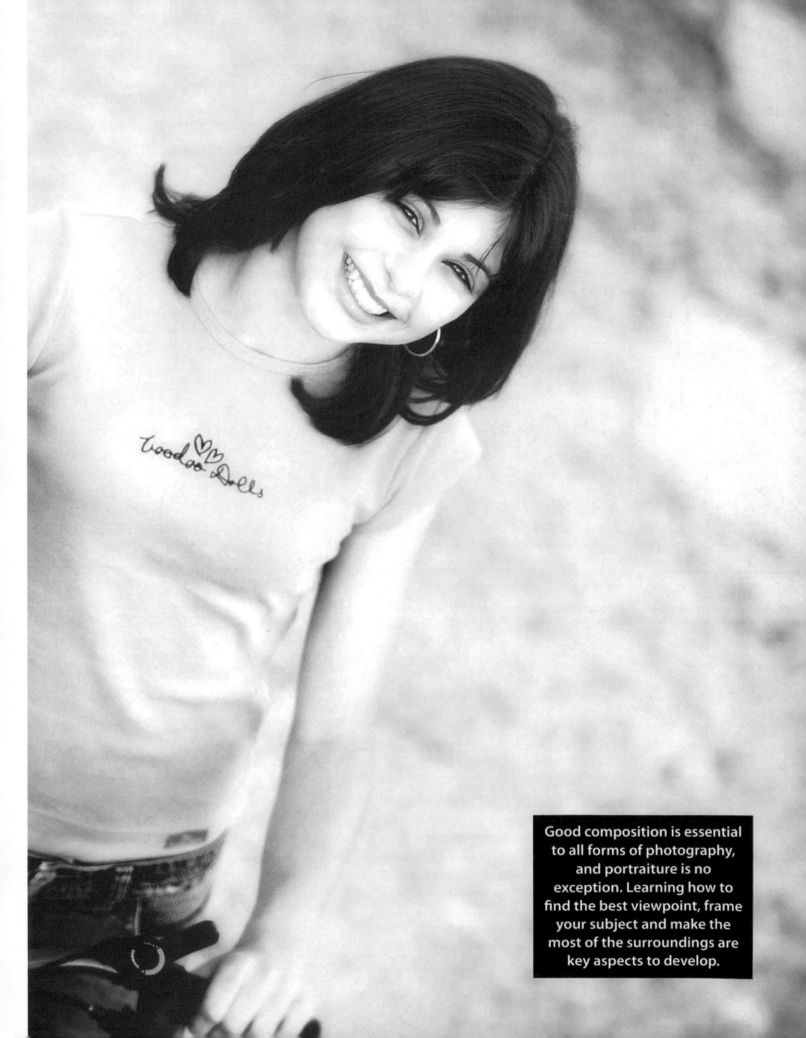

Good composition is essential to all forms of photography, and portraiture is no exception. Learning how to find the best viewpoint, frame your subject and make the most of the surroundings are key aspects to develop.

11 Choose the best format

Many portraits are shot with the camera turned vertically so that the image has an upright format – hence the general use of the term 'portrait format'. However, there is always room for creative experimentation, so consider capturing the image in 'landscape' format, as this can sometimes be more effective.

The decision is one that you can make only at the time of shooting, but there are some considerations that you should bear in mind. The first is how well the background suits the mood of the image. If it is messy and distracting, even when shot with a wide aperture to throw it out of focus, the decision to get in close to your subject and shoot upright to keep the backdrop to a minimum is a sensible one. However, if the background has pleasingly even tones and is unlikely to draw attention away from the subject, or if you can use it to enhance the overall image, then think about including it in the frame.

The other main consideration is how the image might be used ultimately. If you are thinking of supplying the image to a magazine, for example, consider how they might want to use it. A full-page image requires an upright shot, whereas a landscape-format image could be used across a double-page spread, so long as the image is suitable for text to be dropped over the top of it. If you can, try shooting in both formats so that you have every possibility covered.

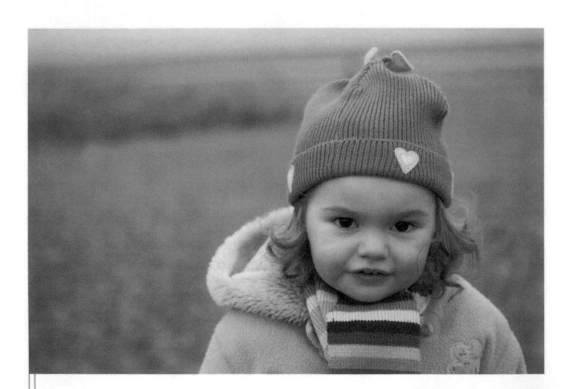

IN THE PINK

Children don't tend to be patient, especially when it comes to having their picture taken, but this subject proved an exception. As well as the traditional close-up portrait (inset), there was time to shoot a landscape-format shot with the subject kept to one side of the frame. The backdrop was ideal, as the tones are even, making this particular image suitable for use on a magazine or book spread with text dropped down the left side. Another reason why this image works so well is that the earth colours of the background are muted and even, so they complement the child's smooth skin tones and her bright and colourful clothing.

Canon EOS-1DS MkII, 70–200mm, 1/250 sec at f/4, ISO 160.

Use the rule of thirds

When composing their paintings, artists often follow a long-established law of composition, simply termed the 'rule of thirds', which determines where key focal points are placed in the image. The rule of thirds has since become established in photography; although it is best known as an aid for landscape photographers, it can be effective for portraiture too. This is most notably the case with the position of the eyes in the frame, as they are often the main focal point of an image. You will normally find that placing the eyes along the upper third of the frame gives the strongest result when shooting close portraits such as head and shoulders. Check out magazine covers with faces on them and you will usually find that the eyes are one-third of the way down the image. With a little creative composition, you can also shift the face off-centre so that the eyes occupy the left or right third of the frame, to give them a little extra emphasis.

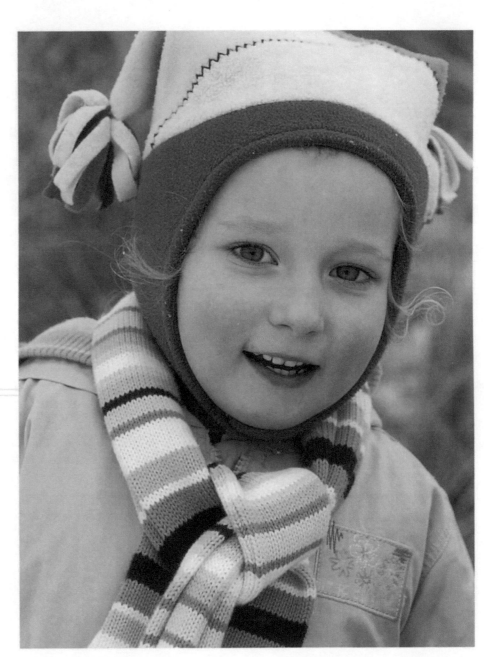

WINTER WARMER

This tight portrait is a good demonstration of a number of fundamental rules of composition. The eyes have been placed along the upper third to give them strong emphasis; this has been heightened by placing them slightly off-centre. Colour also aids the composition: the strong pinks of the hat frame the girl's face, while the stripey scarf leads the eye towards the face. Finally, the slight slant of the subject adds a dash of energy to the image.
Nikon D200, 17–55mm f/2.8 lens,
1/125 sec at f/2.8, ISO 125.

13 Shoot at a slant

More often than not you will choose to shoot portraits from a level position, but there are times when you might want to break the rules to add an extra dimension to your image. One interesting technique is to shoot the subject with the camera tilted at an angle. Far from throwing the picture off-balance, this is actually a very good way to introduce extra dynamism and energy into what could otherwise be a competent but rather ordinary portrait.

Lifestyle and contemporary photographers use this technique quite regularly, in particular when shooting weddings or informal portraiture. It can work particularly well if you are trying to capture the cheekiness and insouciance of lively children. However, be discriminating about when you use the technique; if too many of your images display these jaunty angles, the effect will soon appear tired and overused.

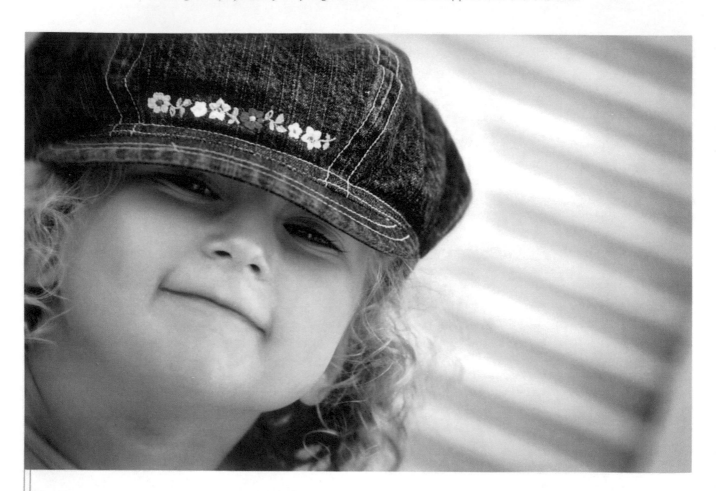

RUBY

Shooting with the camera at an angle works for all sorts of portraits, from full-length body shots to tight crops. For the effect to work well, use a background that makes it apparent that the image has been shot at a tilt. Here, the wooden window blinds, which are out of focus but still recognizable behind the subject, make a perfect background. The diagonal lines make the tilt technique obvious, and the angled slats lead the eye back towards the lively expression on the girl's face.
Canon EOS-1D, 70–200mm at 200mm, 1/600 sec at f/5, ISO 400.

Use unusual crops and exclude the subject's face

It is not always necessary to include someone's face in a portrait. The subject's clothing, accessories, hair or pose can reveal much about their personality, so it is worth looking for unusual crops and angles that could make intriguing images. Concentrate on capturing details and, while including a person in the frame, try purposely excluding their face. This means you can take pictures even if someone isn't looking at the camera or isn't ready to have their picture taken. If you are using a digital camera with a very high resolution, you can create these kinds of unusual compositions on your computer by experimenting with the Rotate and Crop tools. However, nothing beats training your eye and imagination to spot potential images while you are shooting, rather than hoping to discover them when reviewing your images later on.

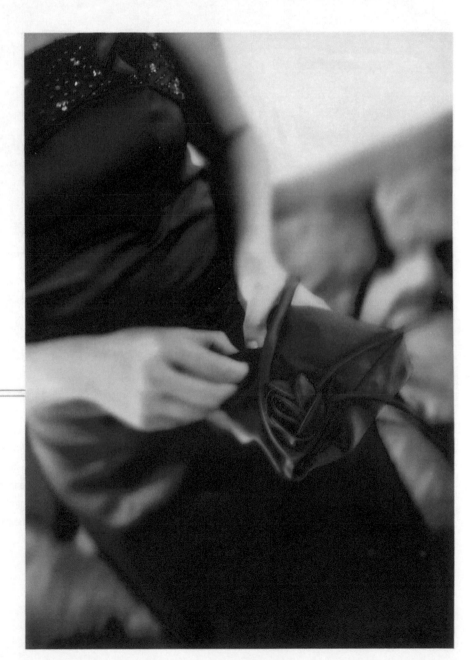

PINK DRESS

There is nothing particularly exciting about a woman holding a handbag, and yet here the photographer has turned this ordinary action into something more interesting. This image works well because the unusual crop and angled composition add energy, as well as allowing the viewer's eye to be led to the main focal point – the bag. Also, the colour of the dress complements the greens of the sofa in the background, and the two combine to create an intriguing, modern composition.

Canon EOS-1D MkII, 17–40mm at 30mm, 1/15 sec at f/4, ISO 500.

15 Seek an alternative view

It is very much the fashion these days to create a reportage-style mood in social photography. This involves trying to capture in your pictures the flavour and atmosphere of an event such as a wedding with the vitality of a real-life situation, rather than relying on stilted formal poses in which the people you are photographing are self-consciously aware of the camera.

Finding unusual views and shooting from alternative angles is a good way to create the feeling in a picture that we are observing the action, rather than everything having stopped for the benefit of the camera.

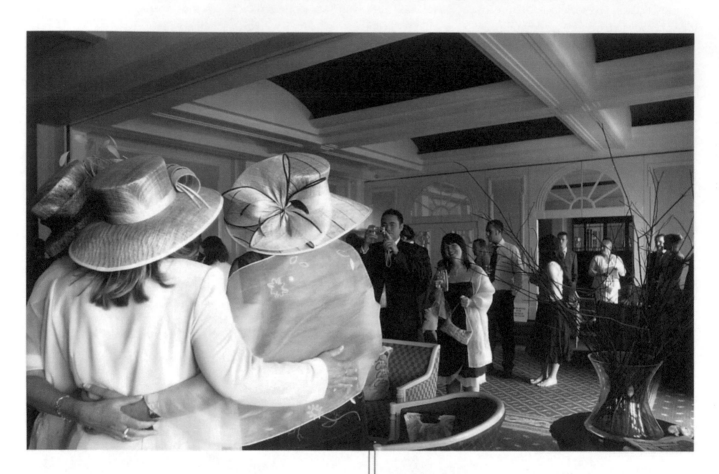

SHOOTING FROM BEHIND

You can achieve interesting compositions by shooting people from behind. This image works on a number of levels. Although the three main subjects in the foreground are depersonalized, their distinctive outfits provide interest from an unusual perspective. There is a clear compositional balance and geometry that heightens the aesthetics of the image, with the foreground dominated by the figures and the ceiling beams providing a strong frame.

Canon EOS 10D, 16–35mm at 16mm, 1/125 sec at f/2.8, ISO 400.

Divide the picture space

Creating a deliberate imbalance by using a visual division or an expanse of empty space in the frame is a simple and effective method for making strong graphic portraits. Empty space can provide weight, balance and intrigue, so a tight crop of your subject may not always be the best option. Often, this is done for the sole purpose of creating an interesting composition, though images with a clear division may also be part of a brief – for instance, magazines that require space for text to flow over may request that much of the frame is left empty. When shooting an image in this style, look for something that separates the main subject from the rest of the scene while still connecting all the elements.

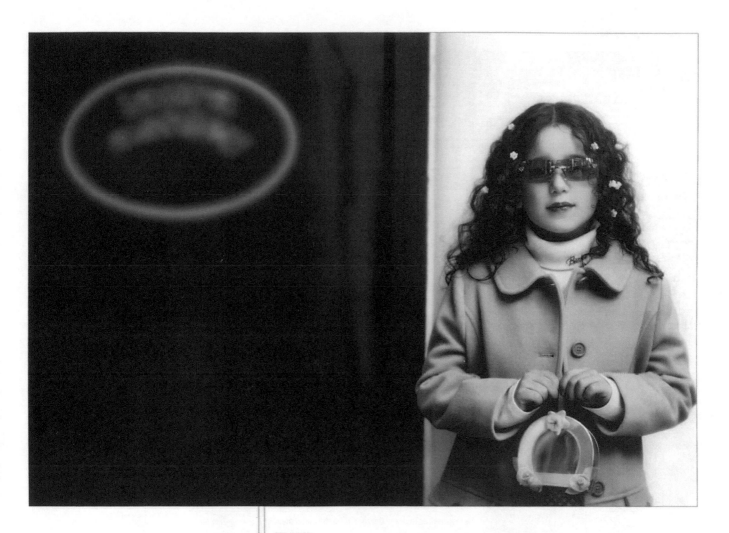

ON SIDE

In this fashion shot, the white background was selected to create separation and emphasize the vibrant pink of the garment. The subject was further accessorized with a pink handbag, hair accessories and glasses; all the elements combine to produce a balanced and themed image. The green wall provides a natural division yet stays connected to the rest of the frame because of the slight overlap of the model's arm.
Canon EOS-1DS, 70–200mm f/2.8 lens, 1/400 sec at f/2.8, ISO 400.

17 Find an unusual backdrop

Many casual portraits are taken without really considering the background at all, but an interesting backdrop can make a world of difference. So think outside the box and search out unconventional settings to add a more effective element to your picture. Look for backgrounds that carry their own interest and will add shape, line or colour to the composition without being too distracting – for instance, industrial areas, derelict buildings or weather-worn wooden structures offer good possibilities. The shapes and structures will often suggest interesting ways of placing your subject and composing your picture, setting you on the way to an original and dynamic portrait.

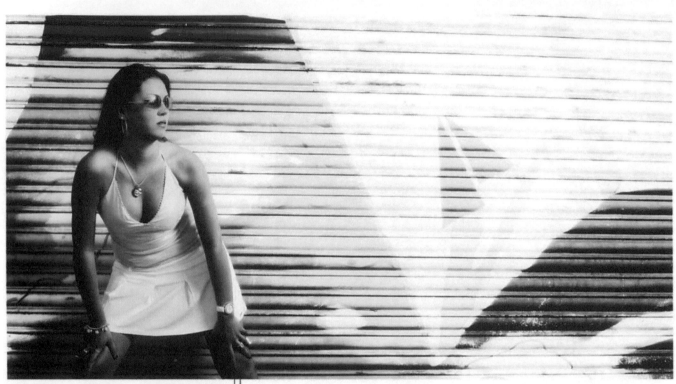

JADE

This image was the result of a fashion shoot that required a bright and colourful shot set in a modern environment. A metal warehouse door with a strong graphic provided the backdrop. Shot in the shade, the lighting was boosted by a portable studio flash, which was placed high and at an angle to add bright highlights as well as to reveal the colours on the metal door.

Canon EOS-1DS, 28–70mm f/2.8 lens at 50mm, 1/125 sec at f/8, ISO 100.

Aim for the back of the head

Photographing the back of someone's head breaks most of the fundamental rules of portrait composition – particularly the one about including strong eye contact in the frame. But that's not to say that you shouldn't try it, as you can produce some very arresting results. The key is to find a subject who has a distinctive feature that makes them worth shooting from behind. This could be an interesting hairstyle or a tattoo – anything that allows the person to be identified even though you cannot see their face. This is not an approach that will work with every subject, but it is worth bearing in mind when appropriate.

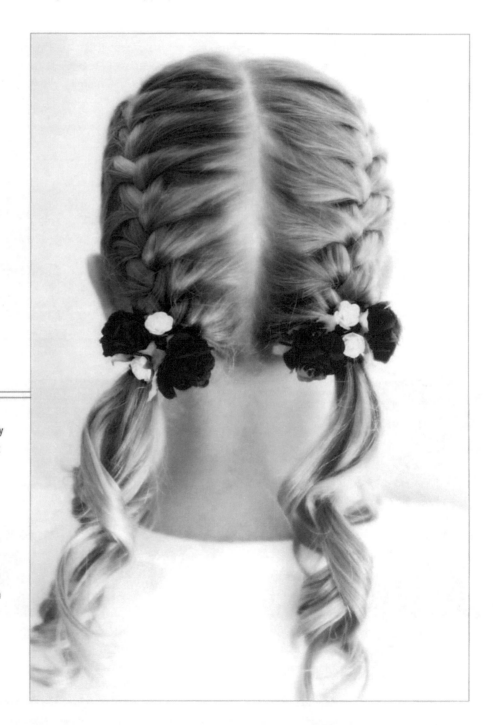

PLAITS AND ROSES

This unusual portrait gives no clues as to the identity of the subject, but still manages to hold the interest of the viewer. It is a very high-key image due to the bright white background, light skin tones and white blouse; this works well as the light tones contrast with the red flowers in the hair, which gain additional emphasis. The hairstyle is key to the success of the shot, as the plaits create interesting patterns, while the hairline and tails hanging to the shoulders all lead the eye back to the flowers, which are the main focus of the image.

Canon EOS-1DS, 28–70mm f/2.8 lens, 1/250 sec at f/2.8, ISO 100.

19 Shoot panoramics

In the past, shooting panoramic images was restricted to professionals who could afford the expensive specialist cameras required to take widescreen images. However, digital technology now allows everyone to try this interesting image format in one of two ways. The simplest is to shoot an image and, having opened it on a computer, crop it to the required width and height. This is very easy, but because you are discarding around two-thirds of the image, the file size is reduced considerably. The best way is to shoot a series of images and then 'patch' them together on the computer. Many cameras are supplied with software that allows this, but you need to take care with the camera positions and exposure to retain consistency.

Whichever method you try, it is important that you look for scenes that suit the panoramic format – for portraiture, this will feature large groups of people in a line. Find scenarios where your subject is located in the central third of the frame, as you will normally remove the upper and lower third. Street or beach scenes are ideal; once you start looking for potential panoramics, you may be surprised by how many you find.

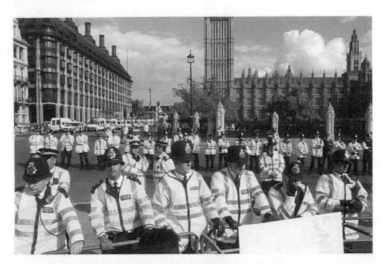

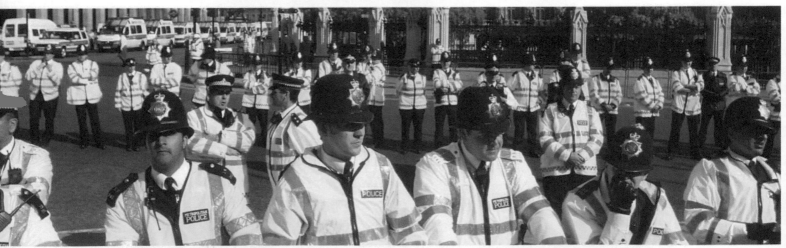

PROTEST

A demonstration in London offered the perfect place to shoot a striking documentary image. While the original shot was notable for the number of police personnel on show, the lateral line of police officers is the focus, as the upper third was filled with sky and the white sign dominated the foreground. Cropping the image into a panoramic concentrates the focus on the lines of policemen in the frame and creates a far more powerful image. Canon EOS 20D, 17–40mm lens at 17mm, 1/000 sec at f/4, ISO 100.

Find a high viewpoint

Changing the height and angle you shoot from is one of the easiest ways to dramatically alter how your subject appears in an image. We are used to seeing the world from our own eye level, so crouching down or taking a high vantage point changes our view of the world considerably. Try this with or without a camera and you will see how everyday subjects – people in particular – look totally different. Generally, it is most flattering to shoot a subject from slightly above, or level with, their eyeline. Unless you are trying to create a particular effect, avoid shooting from a position lower than the subject's eye level.

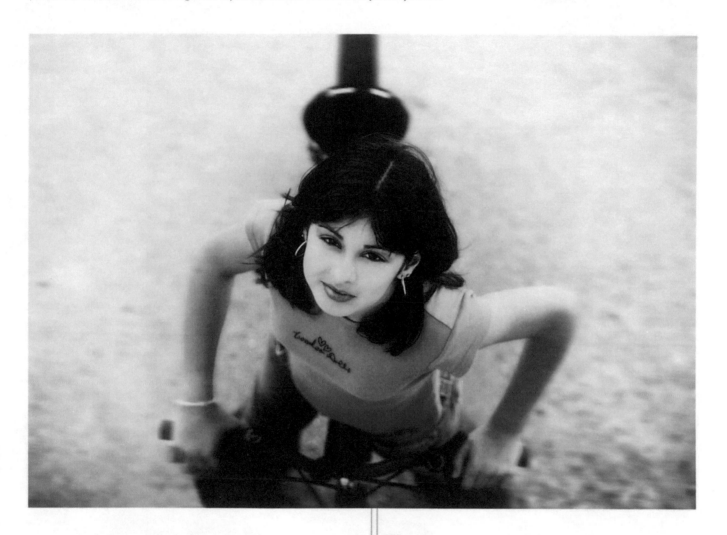

RIO

This image of Rio was taken as part of her model portfolio. The aim was to create an unusual image with an extra dimension and so a very high viewpoint from the top of a wall was adopted. Rio's bicycle made for an interesting prop and her pink t-shirt contrasts well with the grey tarmac. The overcast day gave a very diffuse and non-directional light, and positioning Rio close to a light-coloured wall bounced a soft light on to her face and body.

Canon EOS-1DS, 70–200mm f/2.8 lens, 1/500 sec at f/2.8, ISO 400.

21 Look for dramatic backdrops

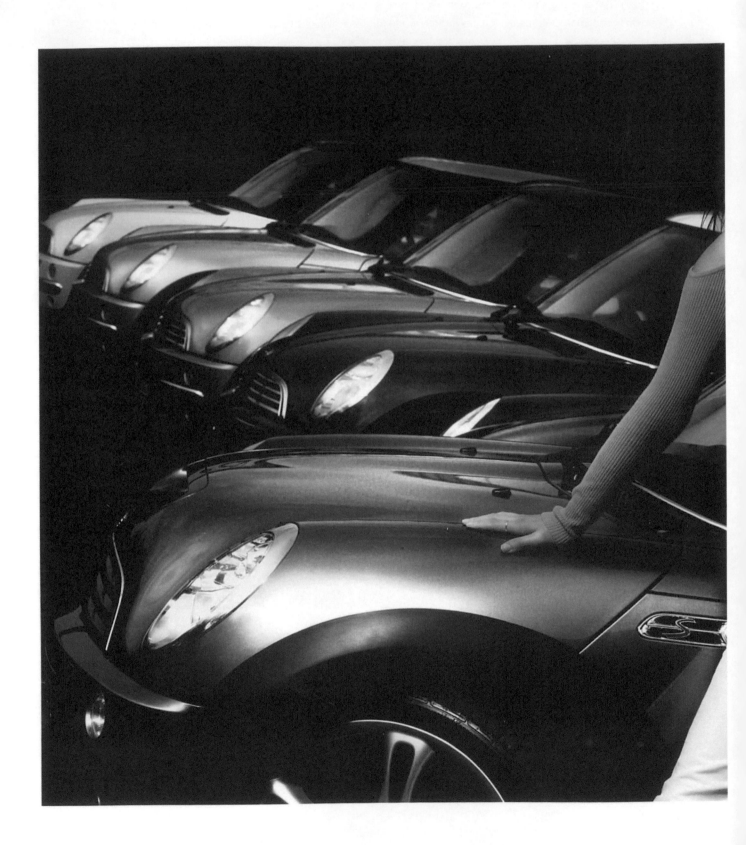

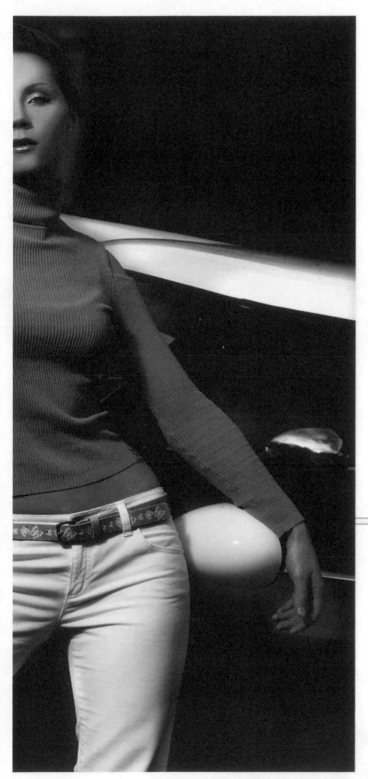

If you are shooting a fashion, lifestyle or mood portrait, while it might seem like a back-to-front approach, there is often no better way of creating a dynamic image than by finding a suitable location before choosing your portrait subject. This means that you can study the characteristics of the location and plan what type of model is most suitable, how they will dress and how you can light the scene.

It pays to be observant at all times and keep an eye out for potential portrait backdrops. Almost anywhere can be suitable, but remember that you will require permission if you want to shoot on private property, while public areas may offer the problem of people walking into your scene or causing distraction. Whether you live in an urban environment or out in the country, there are countless possibilities open to you. When you find a suitable location, study it at different times of the day to see how the direction of the sun affects the lighting. Look at how the tones, textures and colours work together and decide what type of portrait subject will work most effectively.

CHARLOTTE

A forecourt packed with a line of stunning classic cars presented the perfect location for a fashion photo shoot. A quick walk around the scene allowed the best viewpoints to be determined, and a model with a suitably racy look was hired. The contrasting colours of the cars provide interest, and their formation, along with the line of headlights, leads the eye to the model, who has adopted an S-shaped pose with her body to tie in with the rounded shapes of the cars. This shot was taken in bright daylight, but by purposely underexposing the background by around three stops, while lighting the foreground with a portable flash system, it was possible to emphasize the model by making her the brightest area of the frame.
Canon EOS 20D, 70–200mm lens at 70mm, 1/320 sec at f/5, ISO 200.

Controlling the Picture

Creating an original look and turning initial
ideas into actual images isn't always easy, but
following our guidelines on the factors that
determine the mood and feel of an image will
set you on the path to portrait success.

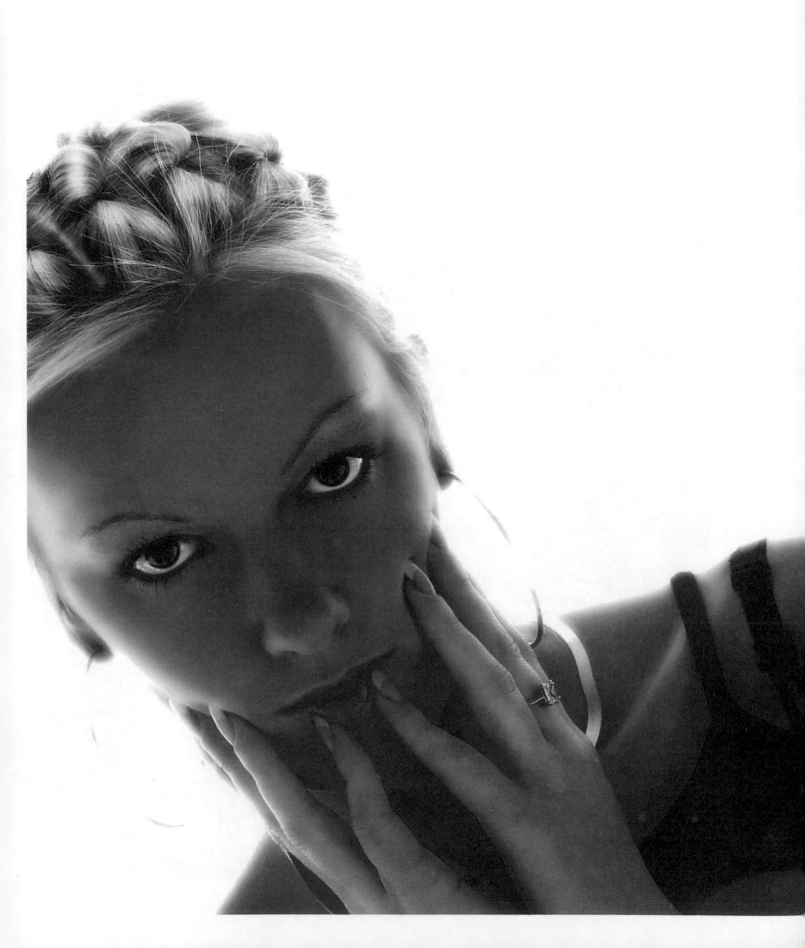

Controlling the Picture

22 Frame for dramatic impact

Your subject is normally the centre of attention, but there is no reason why you can't emphasize their surroundings to enhance the impact of the shot. Framing your subject within elements of the background, using architectural features to lead the eye to the subject, using a wide-angle lens to increase the drama of the background, or using digital-manipulation software to accentuate certain areas of the picture are all ways to create more successful portraits. Use wide-angle lenses with care, however; without strong composition, images can appear cluttered and unappealing, and if your model is small in the frame you need to ensure the environment is interesting enough to hold the viewer's attention.

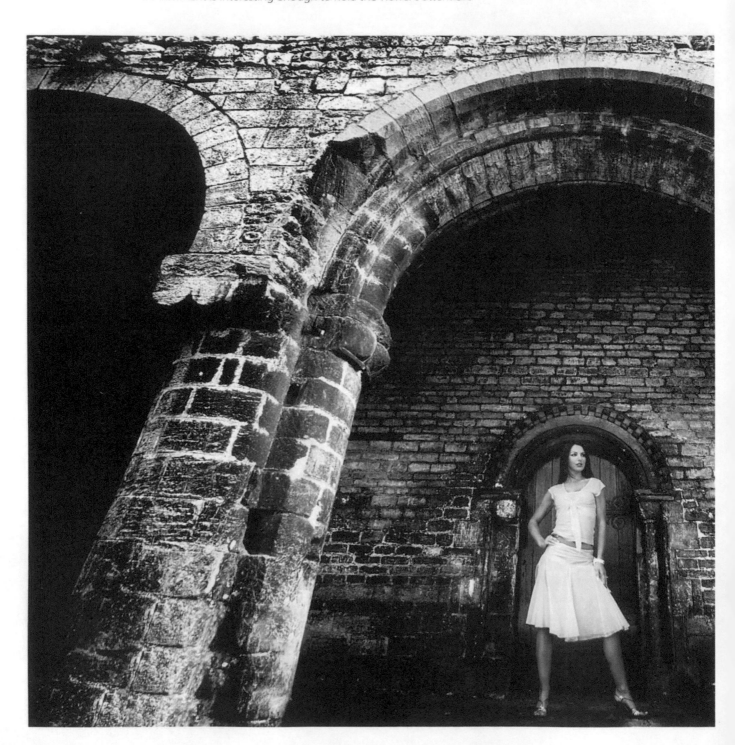

ARCHES

This fashion shoot took place at an ancient priory, and full use was made of the striking architecture. The central archway provides a very strong frame around the model and adds a powerful element to the scene. By shooting from a very low angle and using an ultra-wide-angle zoom, the strong lines of the pillars have been accentuated so that they dominate the frame. This in itself is enough to create a powerful composition, but the image has been enhanced even more through the use of image-manipulation software. The model was selected so as not to be affected by the manipulation work, which was carried out in two stages. The first involved using Curves to boost contrast to emphasize the texture of the brickwork. This also had the effect of deepening the shadows in the darker areas of the frame. The second stage was to select areas of the pillars in the foreground and desaturate the colours until they were almost monochromatic. Removing the colour emphasizes the pillars even more and adds extra interest to the image.

Canon EOS-1DS, Sigma 12–24mm lens at 17mm, 1/100 sec at f/5, ISO 400.

23 Control the emphasis

While the general rule for standard portraits is to try to reveal something of the personality of the subject, it is possible to take a different approach and narrow the focus of attention towards a particular aspect of your subject. This can be achieved using a number of techniques. How you focus on a subject can determine the emphasis of the image – the sharpest area of the model will normally attract the viewer's eye. The way you light the subject is also important, as the brightest area of the picture is normally dominant. The viewpoint (camera angle relative to the subject) plays a crucial role too, as you can frame the subject to emphasize a particular part of the body. You can use all of these techniques together so that your image reveals as much or as little of the subject as you want and leads the viewer to the aspect you intend to emphasize.

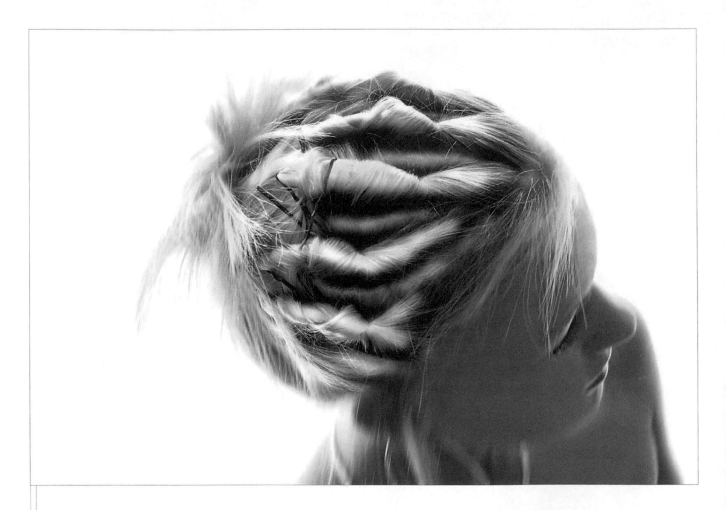

DONNA

The emphasis here is obviously on the model's hair. The photographer has achieved this by adopting a very high viewpoint so her hairstyle dominates the image while her face is de-emphasized. This is unusual, but if you were taking a series of images for a hair salon or a portrait of someone known for unusual or inventive hairstyles, it would make complete sense. The model stood against a huge softbox, which created a pure white backdrop and provided all the lighting for the whole scene. This is also an unusual approach, as the image appears to be lit from several sources. An additional reflector was used to redirect some light back on to the model's hair.
Canon EOS 10D, 28–70mm lens at 40mm, 1/125 sec at f/11, ISO 100.

Use colour to depict emotion

Try exploiting colour in your pictures in order to set the mood and feel of an image. Using one predominant colour in a scene can have a powerful influence on the attitude of those viewing it. Red is the most powerful colour, and its use can suggest energy, power, danger, passion or rage. Green often reflects purity and health (although with portraits it can subconsciously suggest illness, which may not be appropriate). Blue can create mixed moods, so think carefully before using it – as well as suggesting tranquillity, peace and calm, it can also convey sadness, coldness and loneliness. Yellow is generally regarded as a positive colour, and its warmth and brightness suggest sunlight, happiness and joy.

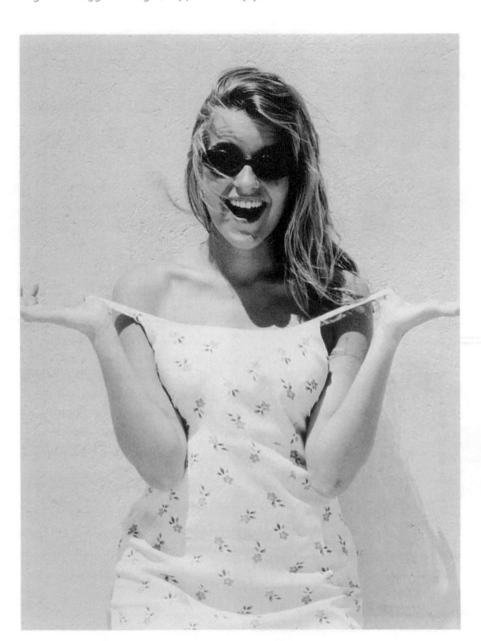

SUNSHINE

This portrait sings with energy and happiness, greatly helped by the choice of the warm yellow tone. The model has adopted a suitably animated and active pose, and her facial expression, pose and general manner convey great energy and positivity. The strong directional lighting also creates a subconscious link between the yellow colour and the warmth of the sun.
Canon EOS 5, 28–70mm lens, 1/250 sec at f/5.6, Fuji Velvia film.

Controlling the Picture

25 Create a melancholic mood

With sombre tones and expressions and thoughtful, reflective poses, a portrait can provoke powerful and complex emotions. While it is natural to want to shoot images that display positive emotions or a 'feel-good factor', thoughtful poses that convey an air of melancholy can also make for beautiful portraits. A cold tonality and a sombre expression are good starting points, but more subtle psychological factors will contribute to a melancholic mood, such as the subject's posture and the focus of their attention – looking downwards implies that their thoughts are deep and reflective. If you try this and find it creatively stimulating, try testing your skills further and shoot images that convey other emotions, whether they are positive or negative.

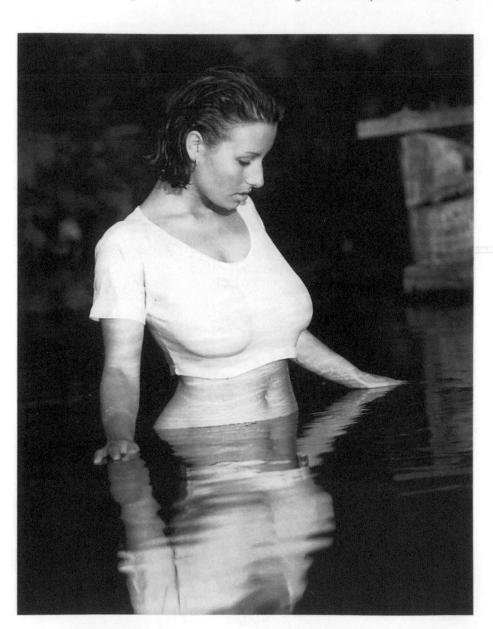

MELANCHOLY

The reflective and melancholic mood in this image has been achieved because the person in the frame is on their own, is looking down, and has assumed a pensive expression. The inclusion of the subject's reflection in the frame may lead to the interpretation that she is looking at herself and reflecting on her life or on her recent experiences. A dark backdrop adds to the mood. Giving the overall image a subtle blue tone injects an additional element of loneliness and sadness.
Canon EOS 5, 70–200mm lens, 1/125 sec at f/8, Kodak TMax 100 film.

Leave the interpretation open

Giving clues to a sitter's occupation, interests or personality is usually one of the goals of a successful portrait. But the opposite approach can also be fun – intriguing or even confusing the viewer as to an image's meaning. This offers the advantage that the image can become a conversation piece for viewers, giving a portrait a higher and more prolonged level of interest than a more conventional shot. The technique is the opposite of giving clues to the personality and interests of your sitter; it is about creating a fiction or fantasy that has lots of visual interest but does not communicate any obvious meaning. You might create a scene that is lit in an unnatural or unconventional manner, or include props that do not match the setting or objects that appear incongruous when placed together.

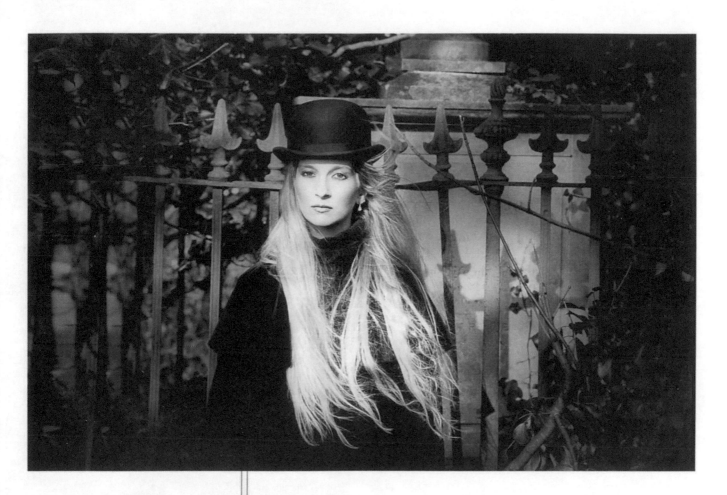

MYSTERY

The concept of this image was to create a very mysterious portrait with a low-key, dark and sombre setting. The choice of a churchyard as the location was a great start for helping to evoke an eerie and even sinister feeling. The subject's attire is designed to bring an extra twist to the image. The bowler hat is a very unusual prop as it is so strongly associated with male clothing. The black velvet cloak is imposing and also contrasts strongly with the model's long blonde hair. The strong, directional light on the subject's face adds contrast and provides a clear focal point for the viewer's eye to settle on.

Canon EOS 5, 28–70mm lens, 1/250 sec at f/2.8, Kodak TMax 400 b&w film.

27 De-emphasize the main subject

If you want to throw strong attention on to a particular prop within a portrait, there is sometimes a case for de-emphasizing the person in your picture. This technique normally applies when there are two or more subjects vying for attention in the frame. Classic examples include wedding shots where the dress is in the foreground and the bride is in the background; advertisements where the model is secondary to the object they are holding or wearing; or when you want to associate your subject strongly with another element in the composition.

One technique you can use to achieve this is to make the person relatively small in the frame, usually by placing them further from the camera than the main subject. Another approach, which ties in with the first, is to use differential focus so that the object is in focus while the person is thrown out of focus.

Another method is to compose the scene so that part of the subject (in particular their head) is cropped out of the frame. An alternative technique is to have the face obscured, with the person looking away from the camera or being over- or underexposed in the frame.

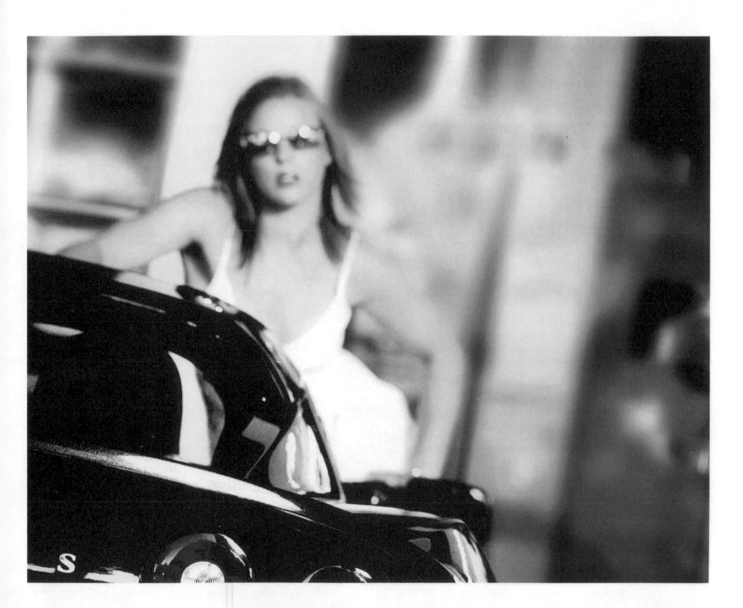

THE HIGH LIFE

The combination of cars and glamorous women has always worked well in photographs, in particular for glamour and men's magazines, as well as in car advertisements. This image takes more of a 'lifestyle' approach; although the model plays an important part in the scene, the main emphasis, by virtue of the focus and the positioning, is given to the car in the foreground. The type of car, the attractive model in the background and the generally sophisticated feel of the shot suggests a wealthy, aspirational lifestyle. While the building in the backdrop was warmly lit by late-afternoon sun, the car and model were in deep, flat shade. The main lighting was provided by a portable studio flash unit. This was balanced to give a similar exposure to the background and deliver a very natural lighting effect in keeping with the ambient light levels.

Canon EOS-1DS, 70–200mm lens at 130mm, 1/200 sec at f/5, ISO 400.

28 Blend the subject with the environment

Successful portraiture often involves ensuring that the subject and the scene blend together well. There is more to achieving this than finding an attractive backdrop and photographing your model against it. Use elements of the background to relate to the sitter; try to match tone and colour; or go for deliberate contrast – it's usually best to avoid clothes with strong primary colours when working with neutral backgrounds, for example. Make sure that your subject's clothes and pose are in keeping with the location. Hiring a professional model can certainly help in this regard. It is also essential to know the best time of day to photograph in a location, and plan what lighting equipment (such as diffusers and reflectors) you will need.

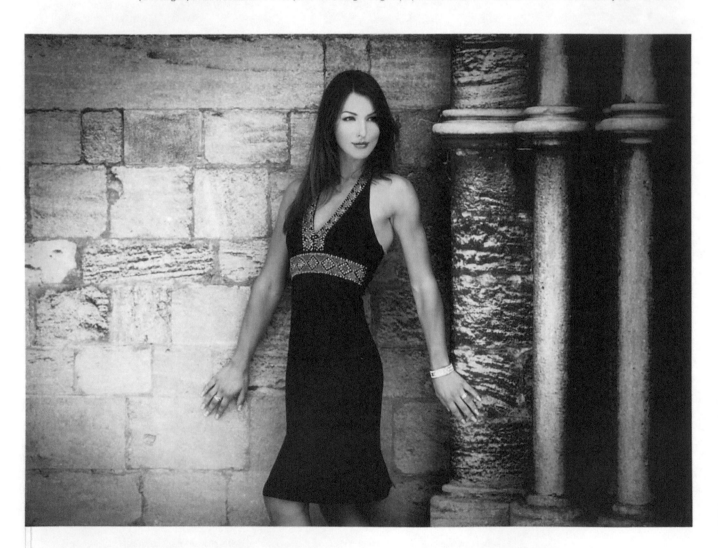

STONEWORK

Here the model is wearing black, which works with most backdrops, including the weathered stonework of this church wall. The model has been carefully positioned to make the best of the scene. The pillars on the right are striking architectural details and, to ensure balance, the model stands on a box so her eyeline is level with the details to her left. Also, her arms, while appearing naturally placed, have been subtly spread open so that the eye follows them up towards her face. The brickwork has been warmed a little, using image-manipulation software, so that it matches the model's skin tones. The texture of the widest pillar has been revealed by increasing the contrast, then applying Gaussian Blur to soften it.
Canon EOS-1DS, 70–200mm lens at 115mm, 1/500 sec at f/2.8, ISO 100.

Add some energy

Although a single image captures a frozen moment in time, that does not mean you cannot convey energy in the frame. There are a number of techniques you can employ to do this effectively. The most obvious is to have your subject take on a pose that suggests movement and action, but you don't need to leave it there. Use tricks such as having your subject wear bright clothing and look excited, as this will add to the 'buzz'. Using strong, directional lighting to increase contrast also works; combined with strong, bright colours, this really helps to raise the impact of an image. You can have the subject actually move during the exposure, or simply simulate movement and use a fan to blow their hair behind them to create the effect of movement.

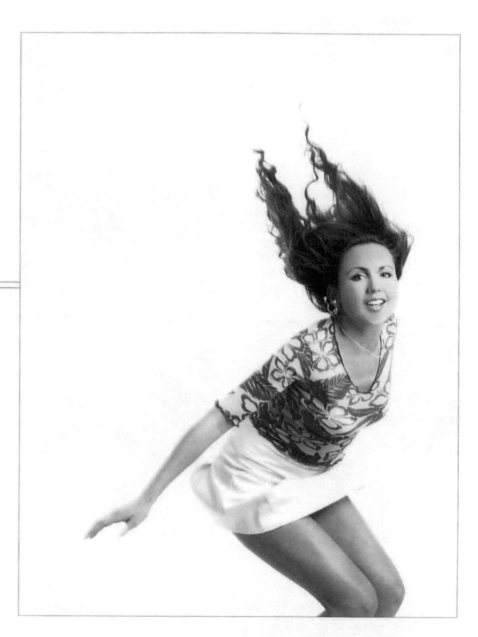

KATE

This subject is well known for being an active athlete who is always lively and on the go: the image aims to communicate this. Although she is completely static, the image shows energy in a number of ways. The pose is probably the most obvious one, but it is worth noting how the framing of the subject to the bottom right subconsciously suggests she has leapt from the top left of the frame. A fan blowing her hair upwards and behind her reinforces that belief. The strong lighting, bright white background and vibrantly coloured top help add extra energy, while digitally cross-processing the shot adds a touch of heightened contrast.

Canon EOS 10D, 28–70mm lens at 50mm, 1/125 sec at f/11, ISO 100.

30 Avoid direct eye contact

Although strong eye contact is often regarded as the key to a successful portrait, pictures where the subjects are looking out of the frame can convey a striking sense of thoughtfulness and intrigue. They leave the viewer guessing what the subject is looking at. We no longer have a relationship with the subject, who appears to be unaware of our presence. We become disengaged observers of the subject rather than being directly involved. The direction the subject looks in often suggests an emotion – looking down may imply sadness or despair, while peering up may suggest frustration or inspiration.

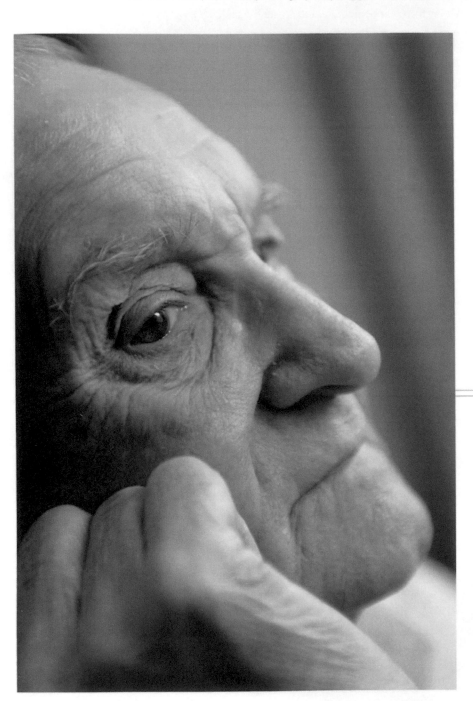

DICK

This portrait works well even though the subject is not looking at the camera and only one eye is visible in the frame. The position of the head, the hand and the direction that the subject is looking in suggest that he is perhaps anticipating an arrival. The lack of eye contact makes it feel that we are able to observe his unguarded behaviour unseen. By zooming in tight and using a very shallow focus, the eye takes prominence in the frame and is clearly the focal point of the image. The subject is illuminated by windowlight, with a white reflector adding highlights on the forehead and nose.
Canon EOS-1DS MkII, 28–70mm f/2.8 lens, 1/80 sec at f/3.5, ISO 320.

Exaggerate contrast

The tonal characteristics of an image are determined by the contrast. The lower the contrast, the flatter the result, which makes it a suitable choice in harsh light; the higher the contrast, the fewer tones that can be visualized and the bolder the result. Although it is only suitable for certain types of images, high contrast can be used to create very graphic images that have bold, distinctive shapes and forms. Film users can achieve this by using high-contrast films and, if shooting in black and white, using a red colour filter on the lens and a hard printing grade of paper. Photoshop users can achieve similar effects using the Levels or Curves functions. This is a technique that could be worth trying if the scene is a little mundane and you want to make the image more bold and graphic.

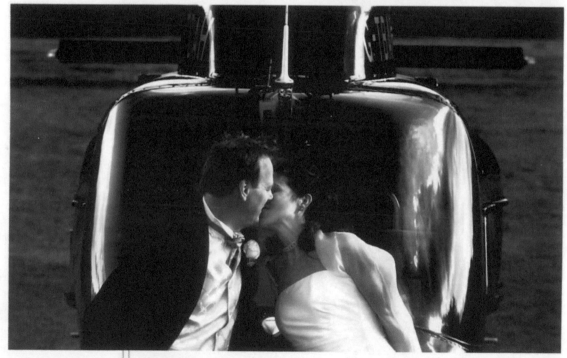

BOOSTING IMPACT

This image was originally taken in colour, but the dull light meant that it lacked impact and it was therefore converted to black and white. This improved the image, but it still lacked any real drama. However, the prominent and interesting shape of the helicopter offered great potential. By increasing the brightness and contrast the graphic nature of the backdrop is heightened, and the composition becomes far stronger.

Canon EOS 10D, 70–200mm f/2.8 lens, 1/500 sec at f/6.7, ISO 400.

32 Express a lifestyle

The environment and atmosphere of a portrait have a tremendous influence on the way we view the image, which makes it possible to represent a certain kind of lifestyle, be it health, business, country or urban. Keep all the visual clues subtle and have them blend naturally into the image. You can do this in a number of ways: the most obvious is to choose a setting that gives a strong representation of the lifestyle you wish to illustrate and combine this with subjects that fit in perfectly with their surroundings. The subject's clothes, hairstyle and general appearance, including props such as spectacles or a briefcase, should all tie into the theme. You will find that it is possible to create any number of lifestyle portraits using the same model, simply by changing their clothing, surroundings and appearance.

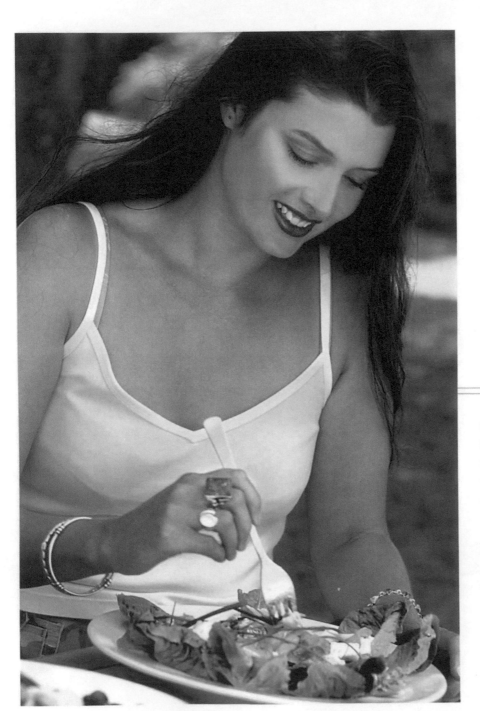

A PICTURE OF HEALTH

Everything about this image suggests a picture of healthy living. The subject is attractive and looks healthy thanks to her flawless complexion and clean white smile. To emphasize her healthy lifestyle, she could have been photographed jogging or working out in a gym, but here she is shown enjoying a salad. The feel-good factor is enhanced by placing the scene outdoors to depict a warm summer's day. Canon EOS 10D, 28–70mm f/2.8 lens, 1/125 sec at f/4, ISO 100.

Make a timeless portrait

We have looked at a number of ways of using settings, props and clothes to influence the way we view a portrait. Often these things give clues to when the picture was taken. This can be historically interesting but from a commercial point of view it can 'date' the picture and make it less saleable. It can also simply be distracting, making it difficult to see beyond an outmoded hairstyle or a pair of platform shoes. It is therefore a challenge to try to create a 'timeless' portrait where such distractions do not occur, through simplicity of styling and setting, so that your portrait could have been taken fifty years ago, or fifty years from now.

TIMELESS

This image has a pure, timeless feel – it could have been taken this year or several decades ago. There is nothing in the frame that gives the viewer any clues as to when it was taken. The lack of cars, signs or anything else obviously 'modern' means there is no time reference. The model's hairstyle is natural and there is no clothing to give away any fashion clues. Because of this, the image has not dated in the few years since it was taken and will not do so in the future.

Canon EOS 5, 28–135mm lens, 1/125 sec at f/5.6, Fuji Velvia film.

Special Techniques

There are numerous photographic techniques that can be used to create a distinctive and original image. From lens techniques to controlling ambient and flash exposures, you will find ways to make your own photographic style.

34 Use zoom burst

The creative technique of zoom burst is possible only if you have an SLR with a zoom lens that allows you to alter the focal length during the exposure. Digital compacts normally prevent the zoom from being adjusted while a shot is being taken, so these cannot be used. Although this effect is easy to try, the results can be hit and miss, so a good deal of patience is required to obtain a successful shot.

First you need to select a relatively long exposure (start at 1 second or longer) and position your camera securely on a tripod or monopod. Then, all you have to do is fire the shutter and zoom in or out until the exposure is over. To vary the effect, experiment by using different types of zooms, try zooming from wide to telephoto and vice versa, and shoot at various exposures.

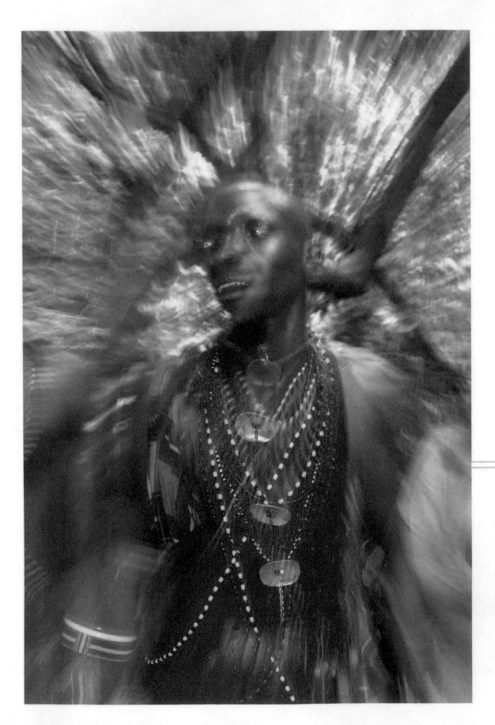

AFRICA

Changing the focal length of the lens during the exposure has created a dramatic zoom burst of this African tribal dancer. To add extra drama, the flash was fired during the exposure to freeze the subject's movement for a split second. Look carefully at the dancer and you can see where the flash exposure merges into the subject's movement and also the zoom burst. The result is a very unusual but effective shot, conveying the atmosphere and energy of the scene.
Canon EOS 350D, 70–200mm, 1/3 sec at f/18, ISO 400.

Add movement to your subject

There are two main ways to capture movement in a portrait. The first is to freeze action with a fast shutter speed. The second is to use a slow shutter speed to capture motion as a blur. With this option, a common technique is to track a subject during the exposure so that it remains sharp while the background is blurred; this is known as panning. However, there are many instances when neither technique is appropriate. For example, you may want to capture a sharp subject, but cannot pan because the subject is not moving across the frame. In this case, it is best to use image-manipulation software such as Photoshop to recreate movement. Applying movement post-production has several advantages. You can control how much of the image receives Motion Blur, as well as its extent and direction. This opens up many creative possibilities, as you have the opportunity to introduce movement that is impossible via conventional methods.

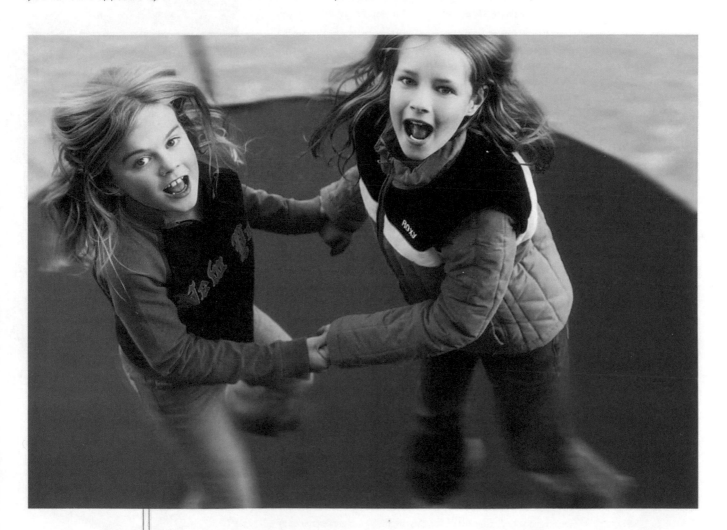

CHILD'S PLAY

The main problem with this shot was ensuring that the subjects were sharp. The point where the children were at their highest was prefocused and the shutter button fired (with the camera set to continuous shooting) when they reached this point. An exposure of 1/200 sec was used to freeze the action and a wide aperture selected to throw the background out of focus. To convey a real sense of movement, Motion Blur was added in Photoshop around the periphery of the frame and to the children's legs and hair.

Canon EOS-1DS, 28–70mm lens at 70mm, 1/200 sec at f/5, ISO 400.

36 Use key shifting

An area of lighting control that is not often mentioned but is commonly used by professional portrait and glamour photographers is key shifting. This involves being able to control the amount of light falling on your subject and how this balances with the amount of light illuminating the general scene. While this can be done using only one main source – for example, daylight – it more usually involves working with more than one light source. The most common type of key shifting involves controlling the balance of ambient (daylight) and artificial (flash) light to create a particular effect. Mixing light sources is not particularly easy, but mastering it is vital if you want to develop your photography and potentially shoot professionally.

Key shifting is a basic exposure technique in which you determine the ratio of ambient and flash light. You need to work out whether ambient light is dominant over flash exposure; whether both are perfectly balanced; or whether flash takes priority.

By exposing for one light source, you are giving it priority over the other, and in effect key shifting. The wider the difference in exposure between the two light sources, the greater the key shift. Using this technique allows you to vary how the subject and the environment are recorded in terms of their exposure. With the flash exposure ensuring the subject is well exposed, you can set the ambient exposure to overexpose the backdrop (i.e., lighten it); underexpose (darken) it; or correctly expose it to create a natural-looking result (i.e., treat the flash as fill-in).

HIGH FASHION

Several techniques were employed to make this image as powerful as possible. The composition, strong diagonal lines, low viewpoint and choice of ultra-wide-angle lens all work to create an image with impact. Add to this careful control of ambient and studio flash light and bold colours and you have a very strong fashion portrait. Here's how key shifting was applied to this scene to give such a bold result: the ratio of flash to ambient light was increased so the amount of flash used was high enough to force down the amount of ambient exposure required. In other words, the scene was correctly exposed for the flash, and, because the flash was at a relatively high setting, the backdrop was effectively underexposed. The result is a correctly exposed subject and a deeply saturated sky (which is effectively grossly underexposed by around three stops). A portable studio flash head with mini-dish provided the flash output. Shooting on a full-frame DSLR allowed for such a wide-angle view. Canon EOS-1DS, 28–70mm lens at 28mm, 1/250 sec at f/22, ISO 100.

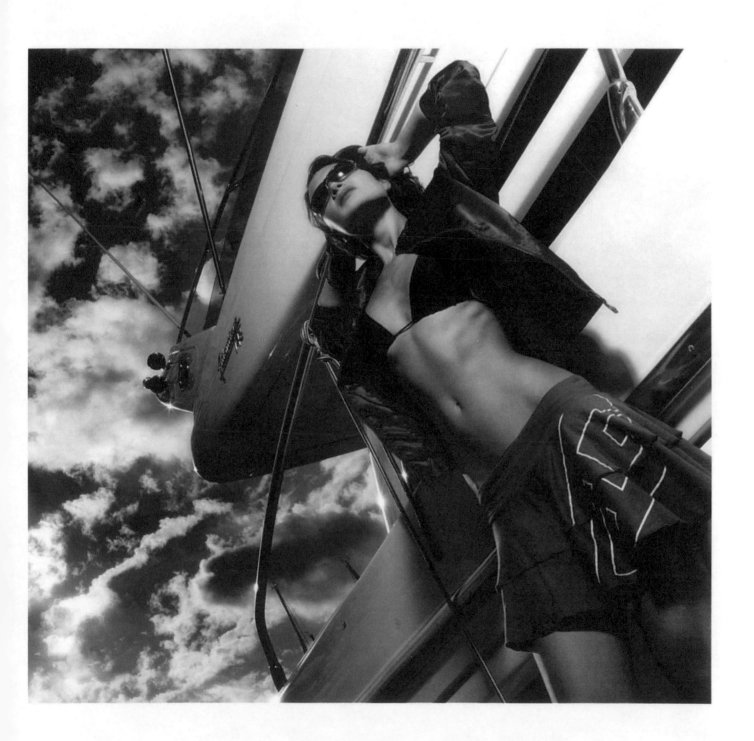

37 Make the environment move

If you want to convey movement in your images, why not have the environment do the moving while you and the subject remain static in relationship to each other? The result is that your subject appears sharp and stationary in the shot, while the background is blurred and active. Make sure you and your subject are on the same platform – so long as you are both travelling in the same direction and at the same speed, the subject will be sharp in the image. Consider standing on a train and shooting the subject in front of a window, on the deck of a boat, on an escalator or any other moving object that can carry both you and your subject.

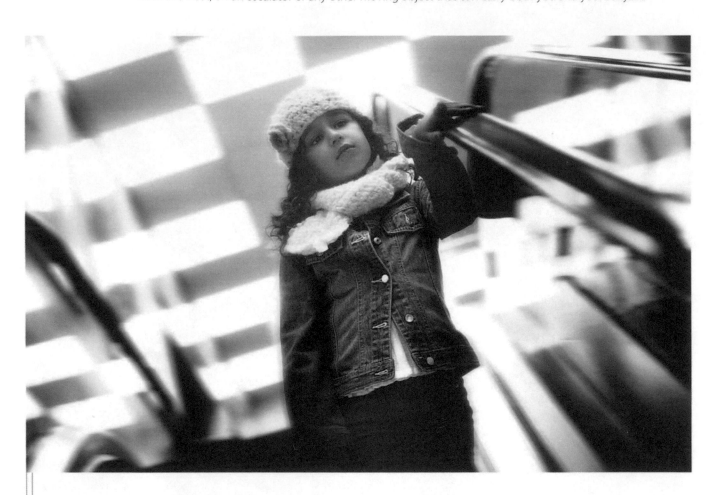

DOWNSTAIRS

Here, the photographer was on the escalator a few steps down from the subject.
This allowed an unusual low viewpoint that also meant the lighting on the
ceiling served as an interesting backdrop. Converting the image to monochrome
eliminated potential problems with colour casts from the artificial lighting.
Canon EOS-1DS, 28–70mm at 70mm, 1/200 sec at f/2.8, ISO 400.

Freeze movement with flash

One of the key benefits of studio flash photography over daylight is that you can use the flash to freeze movement in the frame. By doing this, it is possible to freeze a split second of action on camera, because the duration of the actual burst of flash is extremely short. If you are trying to freeze subjects with flash, you can set your flash synchronization to its highest setting (most modern cameras offer 1/125 to 1/250 sec flash 'X' sync), but slower speeds can be used as the flash output will take place only at the start or end of the exposure as it is so quick.

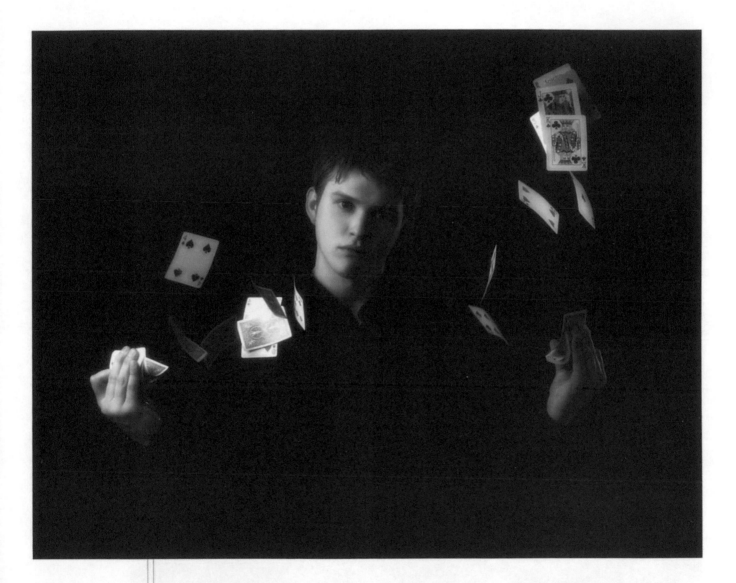

ED THE MAGICIAN

This portrait of Ed spilling a deck of cards from one hand to the other was taken using two flash heads with softboxes attached. The main light was positioned to Ed's right at around 90° to illuminate his face as well as the cards in mid-air. The second light was set three stops lower and positioned at an angle behind him to add shape and rimlight to his left cheek, which would otherwise have been in deep shadow. A reflector close to the camera gives slight definition to his outline. With the lighting prepared, a few shots were needed to catch the cards at the appropriate mid-air positions. The colour image was converted to monochrome and given a subtle blue tone.

Canon EOS-1DS, 28–70mm f/2.8 lens, 1/200 sec at f/8, ISO 100.

39 Tone your prints

While black and white photographs have a deserved reputation for conveying mood and impact, monochrome images can often be improved by toning. There are various types of toners available and the image can take on a number of colours: selenium, copper, blue and sepia are popular. Your choice should be influenced by the type of image you want to tone and the mood you intend the toner to create. Toning your print also serves another purpose, in that it chemically alters the silver salts in the print to make the image more permanent by reducing the rate at which it will fade. Toning kits are available from large photo outlets and via mail-order companies and websites. See pages 138–139 for advice on digital toning.

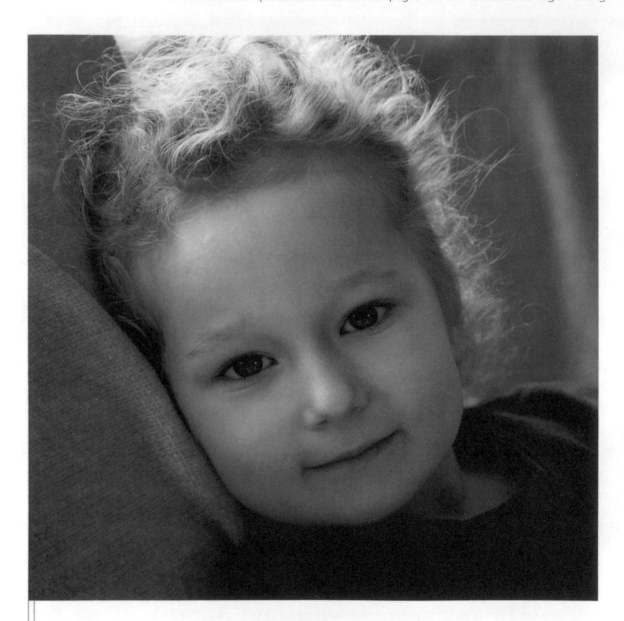

SEPIA TONE

The dreamlike, timeless quality of this portrait made it ideal for sepia toning. The original scene had even tonality, with soft, diffused windowlight giving pleasingly even exposure to the face while lightening the child's blonde hair. The image was cropped to a square format to maximize emphasis on the child's sweet expression. A light sepia tone was used as the contrast is quite low and a darker tone could easily fill in the shadows.

Canon EOS-1v, 28–135mm lens, 1/30 sec at f/5.6, Fuji Neopan 400.

Use flare for effect

Flare is the result of a strong light source (usually the sun) entering the lens and causing part or all of a frame to suffer from a bright highlight and reduced contrast. Flare is usually regarded as a very unwelcome occurrence in pictures. However, this effect can sometimes be used deliberately to enhance an image, creating burning highlights or abstract spots of light that can add dynamic impact to the picture. Creating flare in-camera is relatively easy. Use a bright source of light such as the sun or a spotlight towards the edge of the frame and you will see the flare through the viewfinder. However, although it is easy to produce flare, controlling its strength, its nature and its direction is far more difficult. Photoshop offers an easier method of producing the effect. By selecting Filter > Render > Lens Flare, it is possible to create a flare hotspot and control its intensity and direction. You can even select multiple hotspots if you wish.

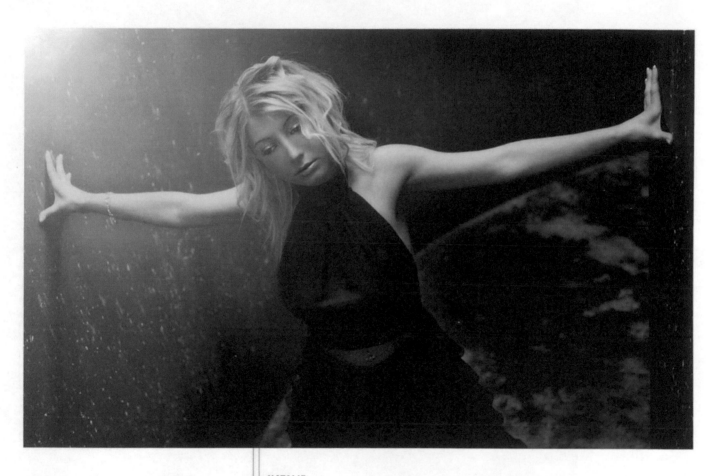

NATALIE

The unusual setting here made for an interesting portrait, but it was felt that something was missing from the shot. By using Photoshop to add flare, it was possible to mimic the effects of a spotlight. Because the scene was predominantly dark, the effects – most noticeably a reduction in contrast in the upper left area – are clearly visible. The flare was controlled so that its effect dissipated close to the subject's face in order to retain detail. This would have been extremely difficult to achieve had a real spotlight been set up on the scene.
Canon EOS-1DS, 28–70mm f/2.8 lens, 1/125 sec at f/3.5, ISO 400.

41 Experiment with ringflash

A ringflash is a very specialized flashgun that is used predominantly by fashion photographers. It is a circular flash tube that sits around the lens and delivers a unique form of light. Ringflash shots are distinctive as they produce a shadowless quality of light on the face and figure while producing an interesting and unusual rim-shadow. It is very direct but can be very flattering as it suppresses skin texture. A ringflash is an expensive accessory and buying one is beyond most budgets. However, they can be hired from professional photo dealers, so why not hire one for a day or two and experiment with your portrait photography?

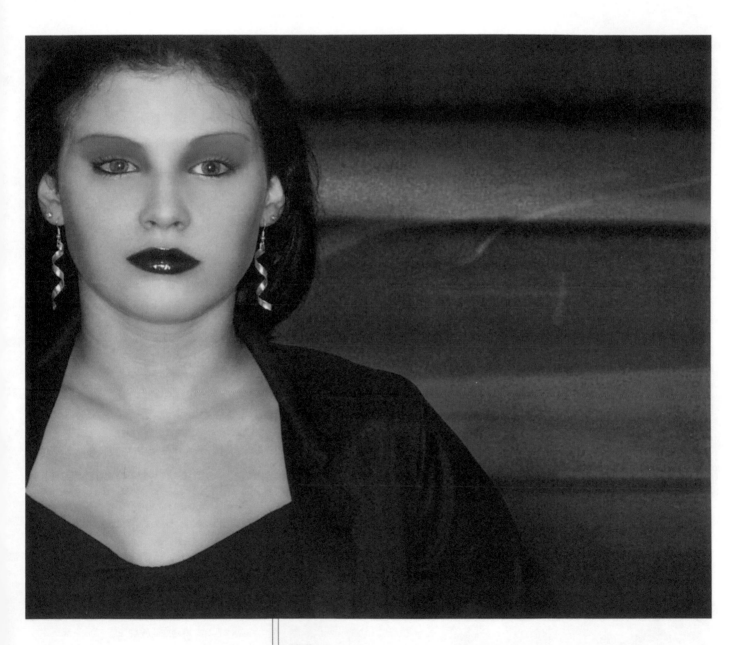

JADE

While ringflash is most commonly used in the studio, it can be used on location if you have a portable studio flash powerpack. For this unusual fashion shot, the subject was placed with a road behind her and the ringflash fired as a blue van passed by. The flash exposed the subject correctly, while a long exposure ensured that the background lights were recorded as a streak of blue and red across the frame.
Canon EOS-1DS, 28–70mm f/2.8 lens, 1/3 sec at f/13, ISO 400.

Special Techniques

42 Shoot through glass

Shooting through glass is not always a great idea because of the risk of capturing distracting reflections. However, you may find you have no choice – for example, if you are shooting through a window. If you are presented with this problem, the following tips could make the difference between success and failure. First, the angle of reflection is relative to the light source – i.e., if light reaches the glass at 90°, it will reflect at 90°. If you position the light source at a narrow angle you reduce the risk of reflection. If working with daylight, try to shoot in the shade. Finally, fit a polarizing filter to your lens, as this will significantly reduce or even eliminate reflections on glass and other shiny surfaces, as well as increasing colour saturation.

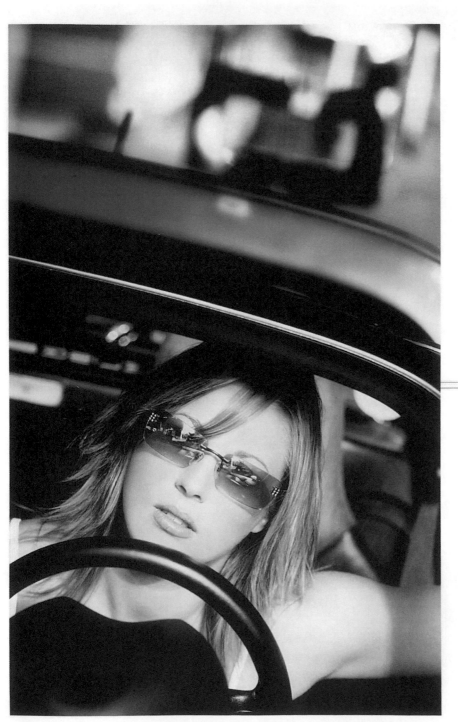

LAURA

Although this image looks as if it were shot in bright daylight, the 'sunlight' illuminating the model is in fact a burst of flash from a portable flash outfit. The light was positioned above and to the right of the camera and angled down at around 45° to ensure there were no reflections off the windscreen. By parking the car in front of a hotel under cover, there was no risk of the sky reflecting off the glass either. This image won Bjorn Thomassen the BIPP's Fashion Photographer of the Year award (Western Region) in 2005.
Canon EOS-1DS, 70–200mm f/2.8 lens, 1/200 sec at f/5, ISO 400.

Work with wide-angle lenses

Although wide-angle lenses would rarely be the first choice for most portrait styles, they do have their uses. They are particularly handy in portraiture when you use their broad angle of view to include the subject's surroundings in the frame, and the accentuated depth can add a sense of movement and excitement. Wide-angles increasingly distort the image towards the edges of the frame, so you should place your subject in the centre if you want them to appear more natural, or place them at the edge to really make a feature of the distorted perspective.

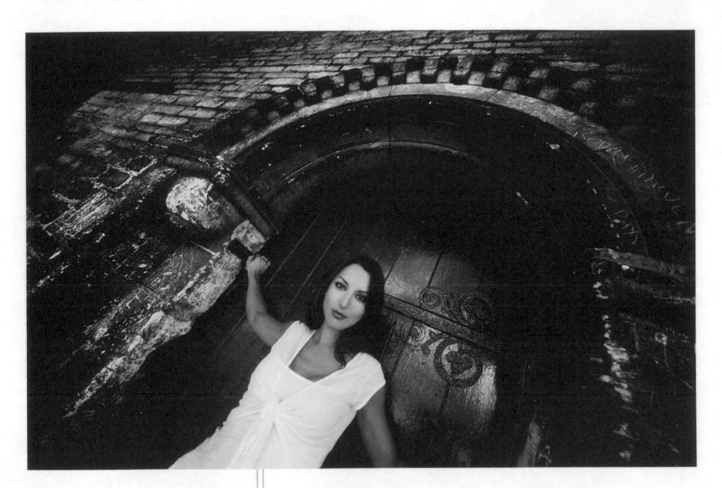

DISTORT THE TRUTH

There is no denying the drama and distortion created by using a wide-angle lens. In this image, the aim was to shoot a portrait against this stunning Saxon architecture while ensuring both were prominent in the frame. A Sigma 12–24mm ultra-wide zoom used at its widest focal length ensured that deliberate distortion of the arch was maximized, and by getting in very close to the model and shooting from a low angle, the main subject is prominent in the frame. By keeping the model central, the distortion of her features is kept to a minimum. Canon EOS-1DS, Sigma 12–24mm lens at 12mm, 1/50 sec at f/4.5, ISO 400.

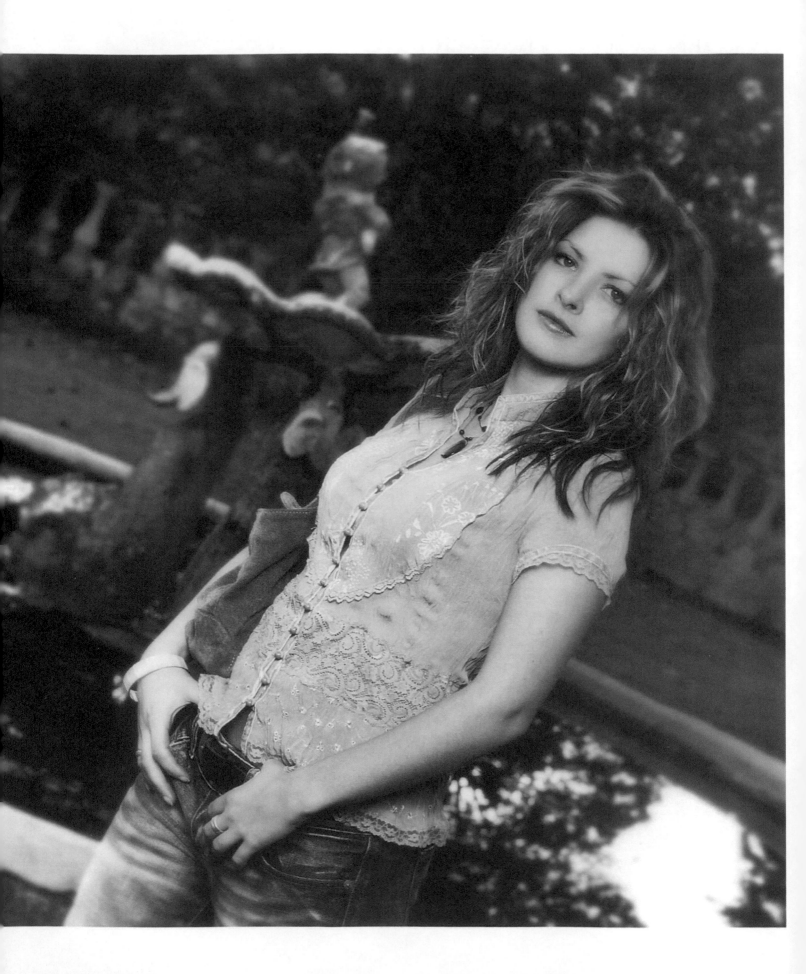

The great outdoors offers enormous potential for shooting wonderful portraits. Regardless of the weather, using creative techniques and making the most of the scenery will help you shoot a variety of great images.

44 Make use of the 'magic hour'

The last hour of the day, when the sun is low in the sky and on its way to setting, is often referred to by landscape photographers as the 'magic hour'. This is a time when the colour temperature becomes much warmer, bathing the scene in a wonderful golden light that lends a special appeal to photographs. Of course, it is not only landscape photographers who can take creative advantage of this period of the day – portrait photographers who are shooting outdoors will also find that it has great appeal. The warmer light of late afternoon and early evening is particularly good if you are shooting subjects who have pale skin, as it helps to give them a healthy-looking glow. This time of day also works well for creating a strong natural backlight to your subject. The low position of the sun means that you can position the subject between it and the camera to create a golden glow around their outline and hair. If you use reflectors skilfully, it is possible to reflect light back on to the subject's face, should this be necessary.

GOLDEN LIGHT

If it weren't for the sunlight highlighting this young girl's hair, it would be difficult to tell at what time of day this image was taken. As it is, the beautiful golden light really lifts this image, particularly because the rest of the subject is in shade. The difference the golden light makes is remarkable when compared to the rest of the scene. The low-lying sun, which is only minutes away from dipping below the horizon, projects a very warm light that is travelling almost horizontally on to the scene. This means that rather than being lit from above, the bridesmaid is sidelit by the sun, revealing her curly hair with an attractive golden light.
Canon EOS-1D MkII, 70–200mm at 200mm, 1/250 sec at f/4, ISO 160.

Shoot in the shade

Novice photographers often mistakenly believe that the best lighting condition for shooting portraits is bright sunlight. The truth is that this gives a very harsh and unflattering light that creates too much contrast, brings out skin imperfections, can make the subject squint and risks flare in the images. A softer, more diffused light is always preferable. If you are shooting on a bright day and do not have a diffuser to hand, then head for a shaded area. You will find light levels will still be good enough to take handheld images, while the soft, less directional light will be far better suited for portraits. The light in shade can often be a little cool, so it might be worth using an 81B warm-up filter to boost skin tones, or add this later in Photoshop.

BANDANNA BOY

Areas of shade have a flat, non-directional light, but on a relatively bright day this is perfect for portraits. This picture of young Miles was captured in the shaded part of a garden on a bright summer's day. Light levels were good and the light was extremely flattering, giving good even illumination and allowing the camera to capture saturated colour and full detail that would not have been possible in the high contrast of direct sunlight.

Pentax *ist DL, 28–80mm lens, 1/200 sec at f/5.6, ISO 100.

Outdoor Portraits

46 Use fill-in flash with backlight

Often, it is not possible to use reflectors to bounce light back into the frame due to time or space constraints, or, when you are shooting groups, because the reflector cannot cover such a wide area. In this instance, using flash as a fill-in is the best option. Modern cameras and flashguns calculate exposures for you; and with many flashguns offering a zoom head facility, achieving a wide flash coverage is not a problem. Experiment with the flash exposure compensation facility to find the fill-in flash balance that works for you, or, as an alternative, set the fill-in manually. As a general guide, set the fill-in flash to two stops under the ambient exposure to retain a natural effect.

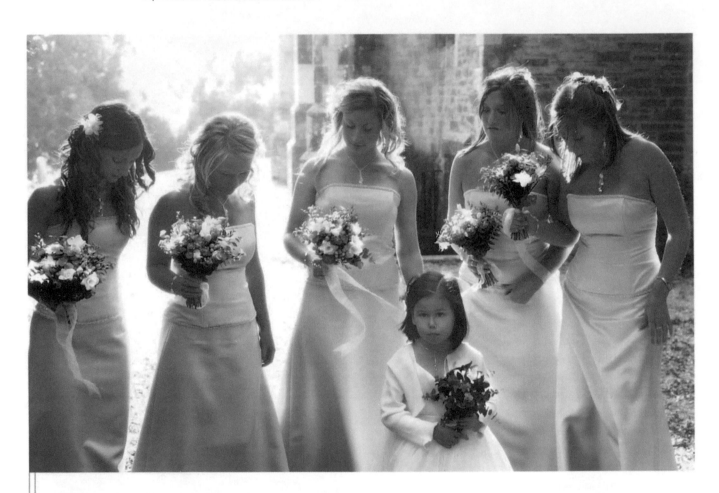

ETHEREAL MOOD

The bridesmaids were unaware they were having their picture taken here as they took a moment to pray before the service. The good use of backlighting from the sun has achieved an almost ethereal feel. With no fill-in, the faces and dresses would have been underexposed and lacking in detail. The use of flash has revealed their faces and the lustrous fabric of the dresses. Care must be taken with fill-in flash – too little and its effect is weak, too much and it can be overpowering. Today's cameras handle the balance of fill-in flash automatically, with the option for you to boost or decrease the ratio of fill-in flash to daylight. To find out what suits you, experiment and adjust your fill-in accordingly.

Canon EOS-1DS, 28–70mm lens at 60mm, 1/250 sec at f/6.3, ISO 400.

Use the sun for backlighting

Backlighting a subject to create a halo-like outline of their hair and body is an excellent way to make the subject stand out from the background. Although this form of lighting is often achieved in the studio using a flash head positioned behind the subject, it is also possible to do it with natural sunlight. The principle is very simple: the subject is placed so that the sun is directly behind them. As the subject has their back to the sun, their face will be in shade. To get around this, use a white reflector (a white diffuser can also work on bright days) placed on the ground and angled to reflect light back up to the subject. By moving the reflector towards and away from the subject, you can vary the amount of reflected light. Because you are facing the subject with the sun behind them, lens flare (caused by sunlight directly entering the lens) is highly likely. The problem can be avoided by positioning your camera so that the sun cannot directly reach it, either by shooting from a shaded area or by having the subject themselves obscure the sun from view.

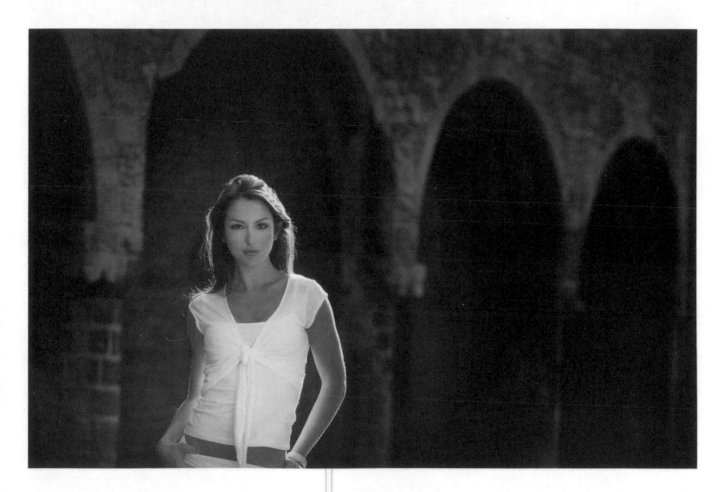

SUNKISSED

This shot was taken with the sun behind the model; the white clothing reflected light on to the model's arms. With this in mind, it is worth ensuring that strongly coloured tops are not worn, or this will discolour any reflected light. We used a white reflector to bounce light back into the subject's face. To warm skin tones, consider using a gold reflector, but take care as the effect can easily be too strong. It is safer to shoot late in the day to add golden highlights created by the warmer light at this time of day.

Canon EOS-1DS, 70–200mm lens at 100mm, 1/250 sec at f/3.2, ISO 100.

48 Add natural fill-in to backlight

When you are shooting a backlit portrait, it is worth bearing in mind that the light that passes over the subject can still be used to provide fill-in to the portrait. If you position your subject so that they are close enough to a existing reflector in the scene, you can use this to provide a natural and diffused form of fill-in. One good example of a reflective surface that is often available is a white wall; this makes a very efficient form of reflector that gives a neutral form of light. Remember that a wall of any other colour will have a major influence on the colour of the fill-in light – for instance, a green wall will give a sickly green cast, while a terracotta wall might create a warm colour cast.

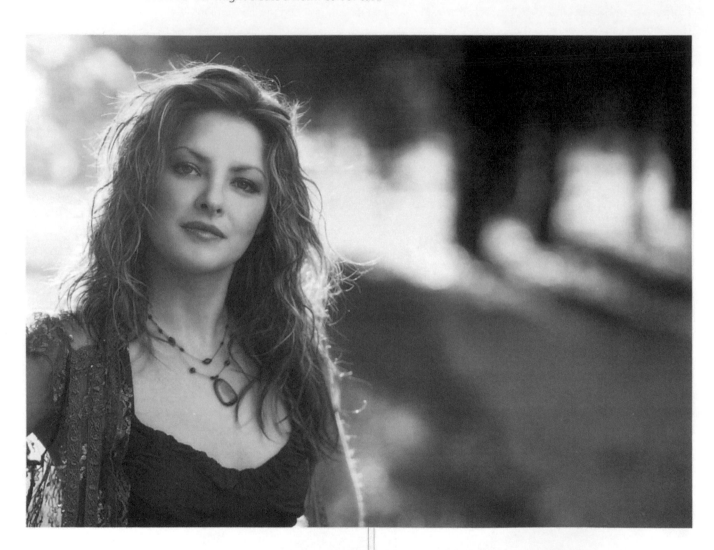

NATURAL BACKLIGHTING

The nature of this model's hair lends itself to backlighting, which reveals its texture and shape and adds an attractive highlight that separates her from the background. With backlighting technique, some form of light on the face adds detail. While fill-in flash or a reflector panel are two options, in this instance, a white wall directly behind the photographer gave a soft, natural balanced feel to the fill-in and was all that was required to give detail to the model's face and body.

Canon EOS-1DS, 70–200mm lens at 120mm, 1/500 sec at f/2.8, ISO 400.

Use daylight for pure white backgrounds

It's a useful technique to be able to create a brilliant white background in an outdoor situation. People assume this effect is only possible using studio lighting, but the truth is that it can easily be achieved simply using daylight and minimal equipment. The principle is the same: to achieve a brilliant white backdrop involves correctly exposing the subject while overexposing the background by anything from one to three stops. To do this, you need to be able to control how the sunlight falls on the scene – this is achieved by using a diffusing panel. By placing the diffuser between the subject and the sun, you not only soften the light, but also reduce how much light reaches the subject so that the correct exposure for the subject will be significantly less than for the background, which will naturally overexpose and record as pure white.

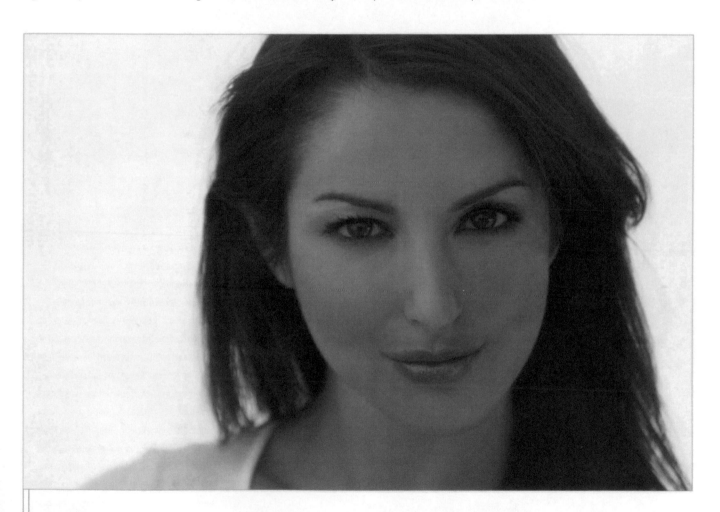

WHITEOUT

When taking a picture like this, choose a background with light tones and ensure that the backdrop is fully illuminated by the sun. You can determine the amount of light loss caused by the diffuser, as most diffuser panels state it; the diffuser used here had a −2-stop effect. Using the spot meter in the camera, or taking a reading with a handheld meter positioned in front of the face, you will take the perfect exposure for the subject. And, because the backdrop is lit directly by the sun, it will receive a higher exposure and so will bleach out to white. In this example, when the meter reading from the subject's face lit by diffused light was 1/250 at f/4, the background was two stops brighter – in other words, 1/250 at f/8. By setting the camera to 1/250 at f/4, we correctly exposed the model's face but overexposed the background by two stops. Canon EOS 10D, 28–70mm lens at 70mm, 1/1000 sec at f/2.8, ISO 100.

50 Use a diffuser outdoors with sunlight

While reflectors generally receive the most coverage in discussions about lighting control, it is important not to forget the key role that is played by diffusers. Available in various sizes and shapes, from round, handheld types to huge panels several metres square, diffusers are perfect for use outdoors to convert the harsh directional nature of sunlight into a far softer and more flattering light source. They are very simple to use; all you need to do is place them between the sun and your subject and the effect is obvious. You will find that diffuser material comes in different densities. These equate to how much light they allow through, with half a stop being a good starting point. If you find the light too even, you can use a reflector to bounce some light at an angle on to your subject.

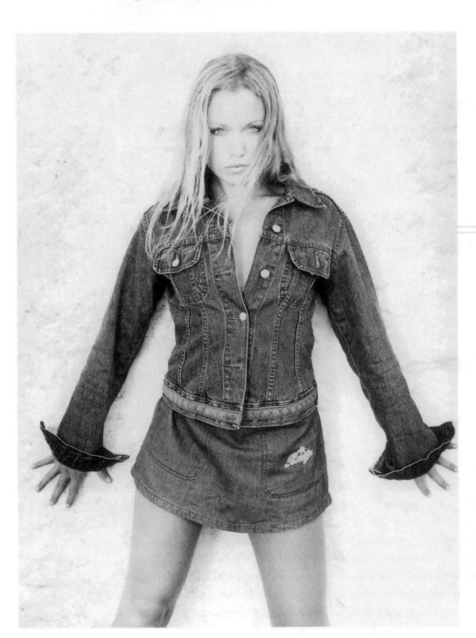

DIFFUSER

A beautiful model and a white wall were all that were required to shoot this simple but striking image. It was taken in black and white for the model's portfolio. The print was tinted at a later stage. The available light was softened using a large diffusion panel positioned between the model and the sun. This lowered the contrast and produced a beautiful quality of light. The lower level of light also enabled the model to face towards the sun without squinting. Although softer, the light still had a strong directional quality. The pose was designed to convey a feeling of stability and balance by using the arms and legs to form an angular base. All lines lead up to the model's eyes; her strong eye contact engages the viewer.

Canon EOS 3, 28–70mm lens, 1/250 sec at f/8, Kodak TMax 400 film.

Balance flash
and daylight

There is no denying the versatility of daylight, but it cannot always deliver the perfect light when and where you need it. You should never be afraid to improve the lighting by using flash along with daylight, to take complete control of the lighting quality and direction. By working to balance the amount of flash output so that it matches that of the daylight, it is possible to take pictures where the use of flash is undetectable to all but the most trained eye. This is simply a case of metering the flash and ambient readings from the subject and ensuring they match, and ensuring that the quality of light from the flash is similar to that from daylight. The control flash gives you also means you can utilize low and atmospheric lighting conditions.

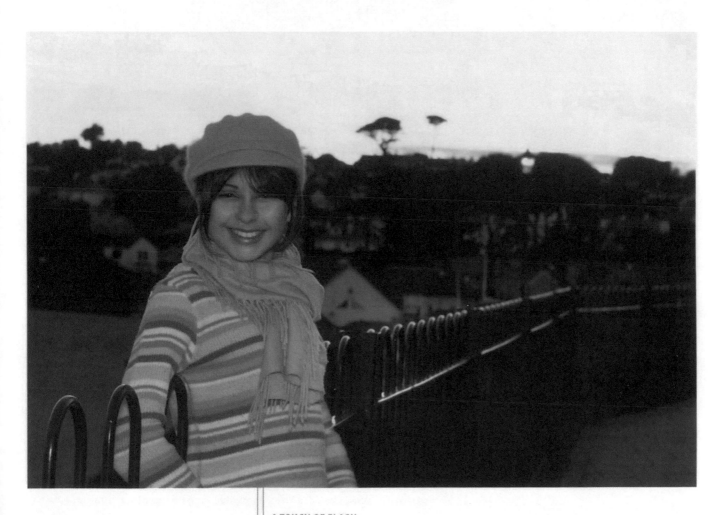

A TOUCH OF FLASH

The arrival of dusk meant additional lighting in the form of a fill-in flash was required to illuminate the subject for this casual portrait. The ambient light level was very low, so the flash would provide the main source of illumination. An exposure was taken for the correct amount of flash to light the subject and the aperture was set accordingly. Normally, this would result in an underexposed background, but using a longer shutter speed ensures background detail is recorded.

Canon EOS-1DS, 28–70mm f/2.8 lens at 50mm, 1/30 sec at f/8, ISO 400.

52 Use slow-sync flash

Modern flashguns offer a whole range of features; one of the least used but most creative options is the slow-synchronization facility (slow-sync flash). This is a tried and tested method for revealing movement in your subject. The technique works by mixing a flash burst with a relatively long exposure, while moving the camera to follow the subject. The flash captures a frozen image of the moving subject, while the long exposure and camera movement ensure the general scene records with a blur. Slow-sync flash is a popular choice with action photographers shooting events such as cycling or motocross, as it adds a dynamic sense of movement to the image. Most cameras feature a slow-sync flash mode, which, when used with a shutter speed of around 1/15 to 1/30 sec, can give very interesting results.

KEIAN

The photographer followed the path of skateboard enthusiast Keian a number of times with the camera to his eye to get used to the skater's speed and direction. Once satisfied, an exposure was taken at 1/60 sec at f/4. The relatively slow speed blurred the background while the burst of flash captured a frozen image of the subject.
Canon EOS-1DS, 28–70mm f/2.8 lens, 1/60 sec at f/4, ISO 200.

Make use of dappled light

Dappled light refers to the play and pattern of light that passes through translucent or semi-translucent objects, creating intricate patterns of light and shadow that can make for wonderful, romantic portraits. It is most commonly seen where sunlight is filtered through a canopy of trees, passing through leaves and twigs. Fencing often creates the same effect, with light passing through wire mesh, slats or ironwork, and reflected light from rippling water can also produce a wonderful dappled light. Look to place your subject in the lighter areas of the pattern to give them added emphasis.

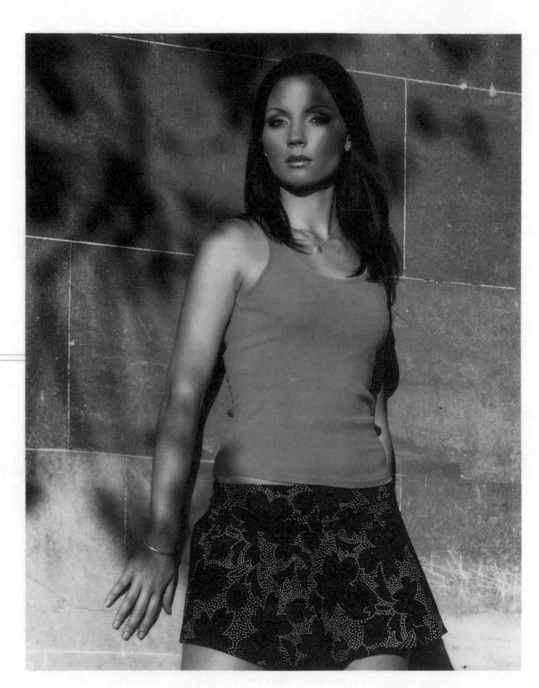

DAPPLED DIVA

This backdrop was chosen specifically to make use of the dappled light falling against it, which was created by strong afternoon sunlight passing through the leaves and branches of a tree. Without the dappled light pattern, this would still be a pleasing portrait, but the play of shadows adds some extra interest. Extra impact is provided by the warm afternoon light, the bold colours of the clothing and the lower than normal viewpoint.

Canon EOS-1DS, 28–70mm f/2.8 lens at 45mm, 1/125 sec at f/6.3, ISO 100.

Indoor and Studio

Mastering light is the key to successful photography, and nowhere offers a broader choice of lighting options than an indoor studio. Whether you are working with windowlight, studio flash or a combination of both, the studio offers the ultimate in control and versatility.

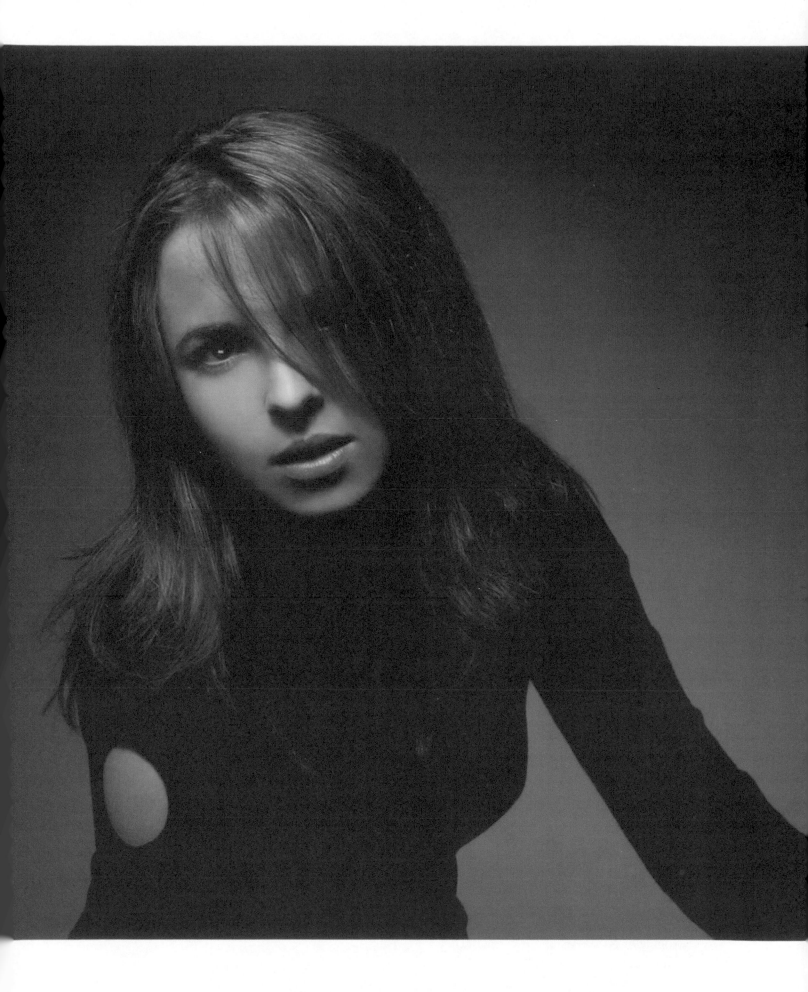

Studio and Indoor

54 Recreate a classic look

Take inspiration from a classic image by one of the masters of photography. Trying to shoot portraits with the distinctive look and style of one of these can be a great way to learn new techniques. In particular, trying to reproduce similar lighting styles will help you develop and hone new skills. With practice and experimentation, you can eventually develop your own distinctive style.

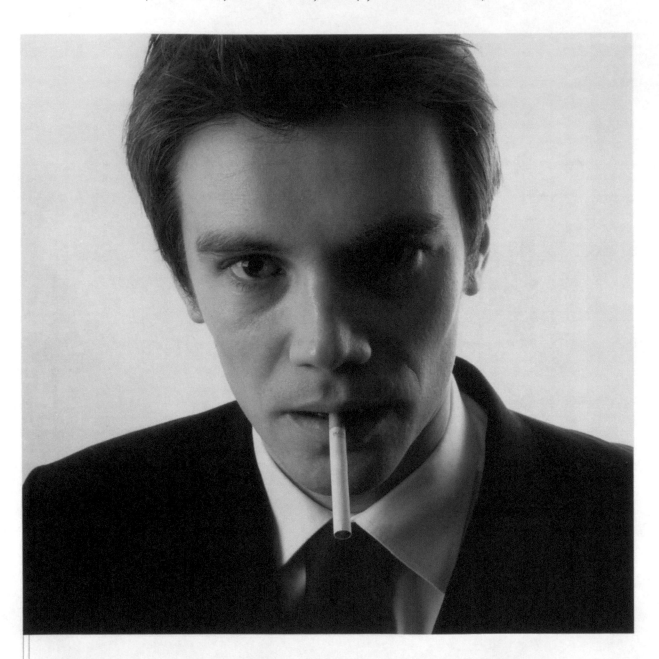

BAILEY STYLE

David Bailey's distinctive 1960s portraits have a timeless feel and should be on everyone's list of styles to recreate. His use of lighting and bold composition made him one of the world's best-known portrait photographers. Here, three studio lights were used to light the subject and ensure a pure white backdrop, while a slightly higher than eye-level viewpoint, with the subject tilted forward, ensured a strong composition. The three lights each served very different purposes. The rear light was aimed at the backdrop and set to high power to ensure a pure white background. The main light, to the front and right of the subject, illuminated the right side of the face, while a third, to the left, provided edge detail to the subject's left cheek.

Canon EOS-1D MkII, 24–70mm lens, 1/200 sec at f/16, ISO 100.

Light for shape

The control that the studio allows means you can create very delicate effects with lighting, using subtle tonal variations to define depth. It is the complexity of shadow, particularly in the darker areas (known as shadow form) that gives modelling a real sense of depth and definition to shape. These shadows play a key role in providing the visual information that we perceive as three-dimensional form. Controlling the direction and strength of the lighting is an essential skill: the contrast is determined by the quality of light and the light-to-subject distance. Varying this will affect the level and intensity of highlights and shadows and allow you to control how you shape your subject's face and figure. A commonly used technique for further control is to use a black board or panel of material to prevent any stray light falling against areas of your subject that you wish to remain in dense shadow.

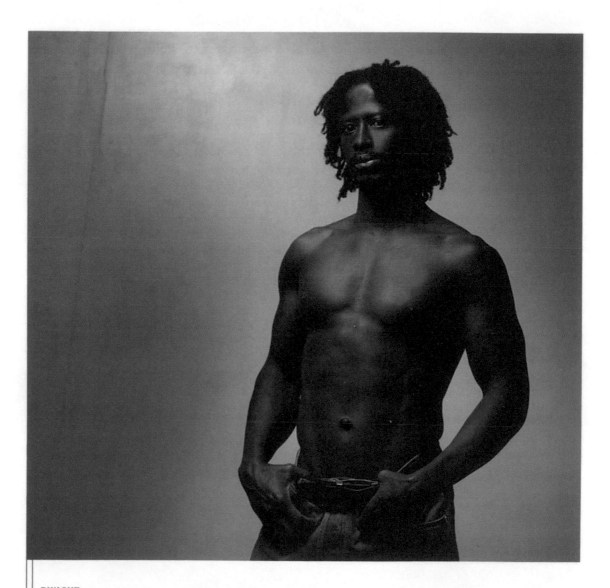

DWIGHT

The aim of this portrait was to reveal the subject's excellent physique as well as his fashionably angular shape and the structure of his face. To do this required creating a flattering light and tight control with the play of highlights and shadows. A single flash head with a white reflective brolly was used. The shaft of the brolly was pushed close to the flash tube; this controlled the size of the diameter of light being reflected against the interior of the brolly and helped heighten the lighting contrast.

Canon EOS-1DS, 28–70mm f/2.8 lens, 1/200 sec at f/5.6, ISO 100.

56 Create depth in even light

A softbox is without doubt one of the most useful accessories a studio photographer can have, as it delivers a soft, flattering light that is wonderful for portraits. However, the downside is that while this diffused light flatters the skin, it also robs an image of depth and its three-dimensional feel. Using a small softbox rather than the standard or larger sizes can get around this problem, as its quality of light, while still flattering, is a little more directional and can be used to reveal the contours of the face and add more depth to the portrait. Using the softbox at 45° to the side and above the subject – a set-up termed 45° lighting – is well known to give flattering light with great shape.

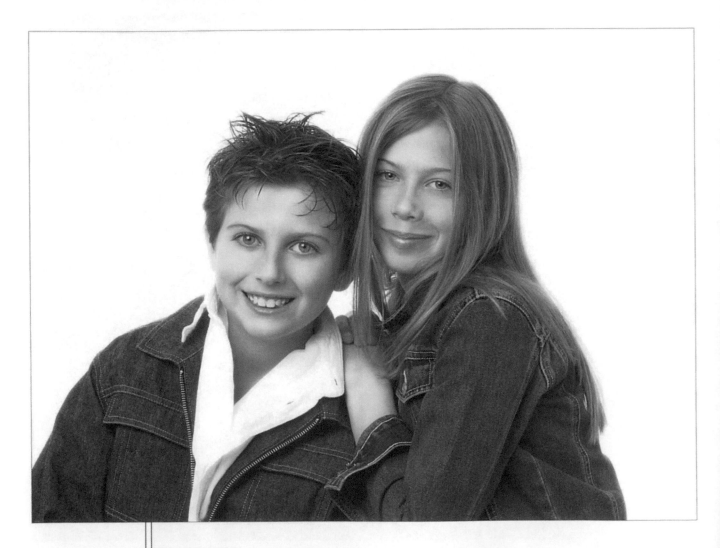

BEST OF FRIENDS

The smooth complexions of these two friends meant that a large softbox for very diffused light was not necessary. Instead, a small softbox was used and set up to the side of the camera and raised high so as to point at 45° down towards the subjects. The resulting light really brings out the shape and contours of the faces, with the soft contrast between the highlights and shadows revealing the subjects' features. By posing the girl on the right at an angle, an extra element of depth is added to the overall image.
Canon EOS 10D, 28–70mm f/2.8 lens, 1/125 sec at f/11, ISO 100.

Control windowlight

The simplest form of indoor lighting is windowlight, but don't think that it is therefore not versatile. The introduction of reflectors and diffusers mean you can control the quality of the light and bounce it back in from different angles. On sunny days you have hard directional light which, if required, can be diffused with tracing paper, a gauze or net curtain. Reflectors allow you to bounce light that has travelled through the window and past your subject back again to fill in shadows on the offside of the subject. A white reflector is the best choice, although a silver reflector is good if light intensity is low, and a gold reflector is useful when you want to add a little warmth to skin tones.

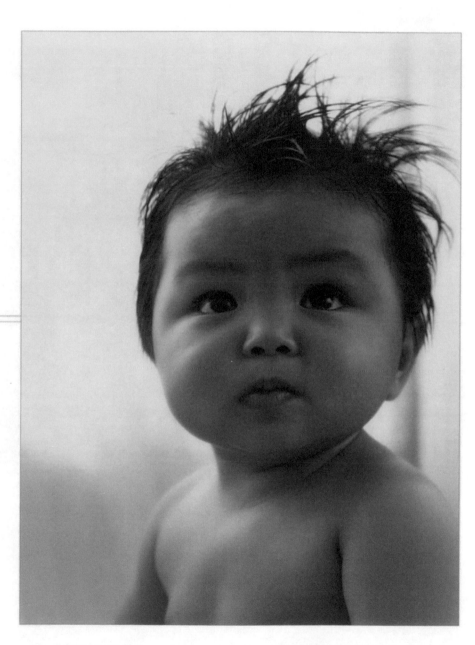

FAITH

Because the light was quite strong on the day this portrait of Faith was taken, a few layers of netting were placed across the window to soften the light and lower the light levels. Faith was placed close to the window as the light being reflected back on to her left side needed to be bright enough to fill in her features. A silver reflector provided the necessary fill-in and a fast speed rating of ISO 800 purposely increased the noise level in the image to soften the result and add atmosphere.
Canon EOS-1DS, 28–70mm f/2.8 lens, 1/125 sec at f/4, ISO 800.

Studio and Indoor

58 Use black reflectors

While white and silver reflectors are routinely used to bounce light back on to the subject efficiently, you should also consider using black reflectors to absorb light and control the amount reaching the subject. This technique is often termed 'subtractive fill'; it is typically used to paint dark reflections against skin or light material, to create shadow form and separate the subject and garments from the background. It is generally underused, but when applied well can add a three-dimensional feeling and bring real depth to faces, accentuating contours. To use black reflectors efficiently, you need to place them close to the subject. For this reason, they are typically used for close head-and-shoulder portraits. Any form of black material can be used; card or paper are suitable, but velvet is maybe the best option as it is so light-absorbent.

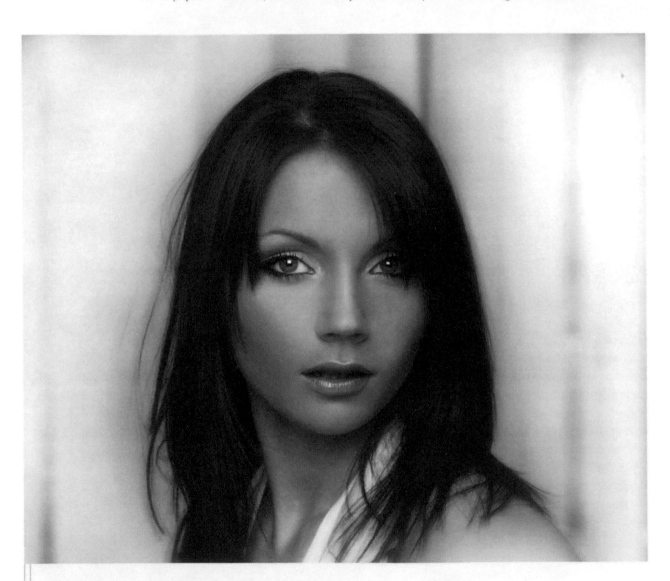

PERFECT CONTOURS

When you see images as effective as this, it is surprising that the use of black reflectors still remains relatively rare. The lighting here was deliberately set up to accentuate the subject's facial features. A small softbox, positioned above the camera, gave a diffuse yet concentrated light retaining some contrast, which would have been lost had a larger softbox been used. Black paper panels were placed to either side of the model's face just out of frame. This has accentuated her features, while her hair has taken on a far darker shade than is natural.
Canon EOS-1DS, 70–200mm f/2.8 lens, 1/4 sec at f/8, ISO 100.

Use windowlight

Do not underestimate the versatility of windowlight for shooting portraits. Although you can never predict its intensity or quality, you can use almost any form of windowlight to take effective pictures. On a bright day, the light can be strong and directional, but is easily diffused using a net curtain or translucent white material, while the soft, diffused light of an overcast day is ideal for flattering portraiture. If you are shooting at home, study the course of the sun over a day so you can get a good idea of which window it is best to work from at different times of the day. When shooting a subject by windowlight, their proximity to the glass will influence the contrast between highlights and shadows, while the angle and position of the subject will determine which areas fall in light and which in shade.

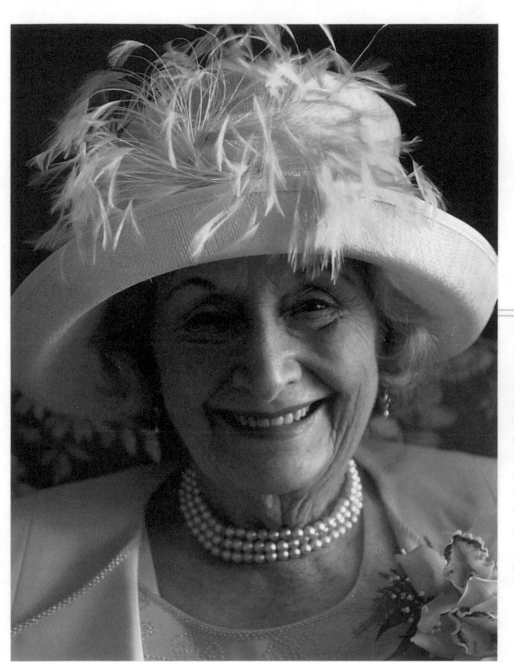

FLATTERING WINDOWLIGHT

A more directional light here would have revealed the subject's skin texture, but the soft light coming through net curtains to her left has bathed her in a flattering light that smooths out some of her wrinkles and softens the skin. Shooting from a slightly higher viewpoint meant the subject had to look up slightly, which ensured that the brim of her hat did not block out light from illuminating her eyes. A beaming smile rounds off a simple but very pleasing portrait.
Canon EOS 10D, 28–70mm f/2.8 lens, 1/60 sec at f/2.8, ISO 400.

60 Make a 'Hollywood' portrait

The term 'Hollywood lighting' describes the lighting set-ups used to create many of the portraits of the cinema stars of the 1920s, 30s, 40s and 50s. In this era, before the development of early studio flash systems, the high-power lamps that lit film studio sets were also used by stills photographers to light their portraits. The results were highly stylish and very distinctive, with a hard, high-contrast quality, yet the photographers' skills ensured that the stars were perfectly lit and classically captured. Similar effects can be achieved with studio lighting by using strong direct light and paying close attention to the deep shadows and the shapes they create. Perfecting the technique requires patience and experimentation; George Hurrell is considered by many to be the master of Hollywood lighting, you can view his work at www.hurrellphotography.com.

Traditionally, the lights used were far more powerful than those used today, so large studios were needed as the light-to-subject distance was considerable. The variety of techniques are vast, from using spotlights for directional light to using the edge of a beam for a soft effect known as feathering. Trying out Hollywood lighting requires the mastering of several lighting skills, so requires considerable homework on lighting set-ups before you can feel qualified to try.

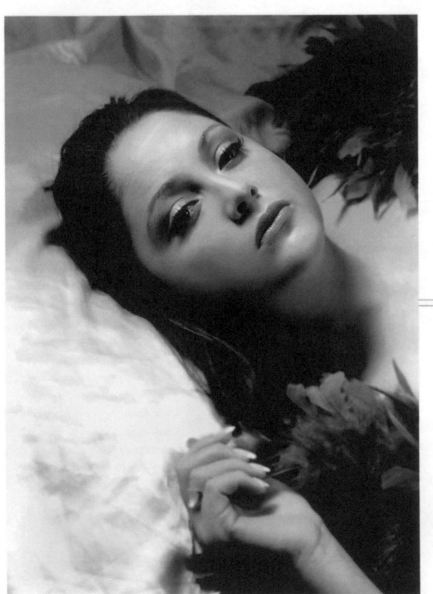

KELLY

The feather boa and satin sheet help to create the period feel of this portrait, which is lit with the harsh directional light characterstic of the style, producing strong, deep shadows. Because the light was so direct, it was important to keep an eye on the make-up and reapply foundation when the model's skin began to shine. The model lay on a makeshift bed and was lit by a single light at 45°, with a reflector bouncing back a small amount of light on to her right cheek. The original colour image was converted to monochrome in Photoshop.
Canon EOS 10D, 28–70mm f/2.8 lens, 1/125 sec at f/11, ISO 100.

Make use of stage lighting

An indoor situation that is often difficult to photograph, concerts and stage shows nevertheless offer a great opportunity to capture colourful and unusual portraits. While the technique is relatively straightforward, many amateur photographers struggle to do it well. This is mainly because most choose to use the integral flash, which yields images that are often underexposed and almost always lacking atmosphere. The secret is to switch the flash off and take the exposure using ambient light only. To avoid camera shake, you should use a high ISO rating (400 to 1600) and shoot at the widest aperture to give the highest possible shutter speed. Using a wider focal length helps avoid camera shake too, so avoid using long telephoto settings.

For any real chance of success, you need to be as close to the stage as possible. Contact the venue well in advance for permission to take photographs – visiting with your portfolio and credentials may help – and offer to shoot at dress rehearsals rather than performances.

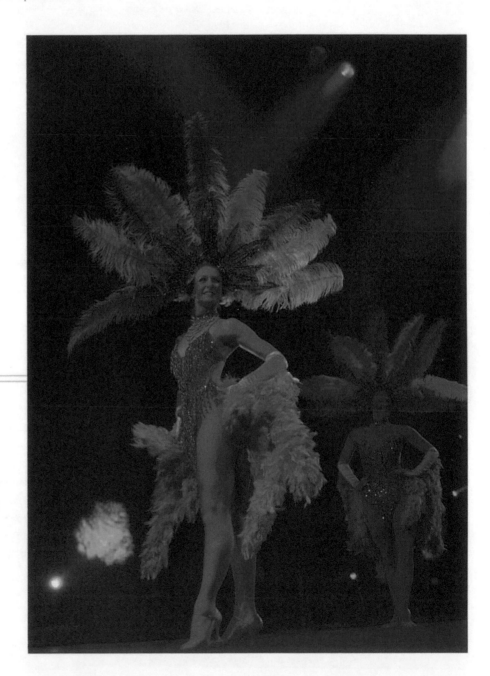

SHOWGIRLS

You are fully dependent on stage lighting when taking pictures at concerts and shows, so good photographers know how to use the colours and effects of stage spotlights to their advantage. Here, shooting at a wide angle emphasized the performer in the foreground, but also allowed the spotlights in the background to be included in the frame to add interest to the overall composition. A fast aperture and a high ISO rating allowed for a sharp image free of camera shake that makes the most of the colourful spotlights.
Canon EOS 10D, 28–70mm f/2.8 lens, 1/125 sec at f/2.8, ISO 1600.

62 Create a menacing mood

A successful portrait evokes emotions from those who view it – and that does not always mean positive feelings. An atmosphere of fear and menace can make for a powerful image, too, and although you will rarely want to make your subject look scary, creating a feeling of edginess and intensity can make for a very strong portrait, particularly of a man. Creating an image with any type of mood is usually dependent on skilful use of lighting in the studio, and this is particularly true when you want to create a menacing effect. Thankfully, although this requires sound knowledge of how to set up your lighting , the actual arrangement is a simple one based on a single light. Using one source and ensuring that the light is small and directional ensures that the contrast is high, the effect is at its hardest, and the result is as strong as possible.

Because the light is so directional, you will find that relatively small areas are illuminated while wider areas are cast in shadow. By changing the position of the light (as well as the subject) you can dramatically change how the subject will appear. Using reflectors (white, silver or black) will help you control where highlights and shadows appear. Of course, the person you are photographing has an important role to play. You must ensure that not only their expression but their entire body language fits the menacing mood. Choosing an appropriate subject (i.e., a frightening character) instantly helps add some threat to the scene, but with the right lighting and expression, even a young child can be made to look menacing!

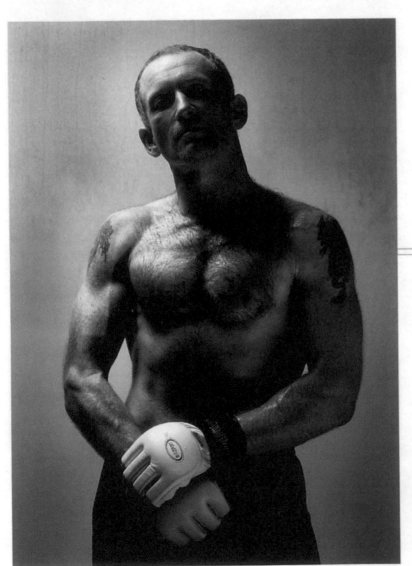

KIM

A single light (with brolly) was positioned high and angled to illuminate the top right of the subject and the background. This set-up also had the effect of throwing the eyes into shadow, which raises unease and anxiety in the viewer. To avoid the whole body being cast in shadow, a triflector was positioned low down to the left of the subject to throw a small amount of light back on to the neck and torso. With most of the face thrown into shadow, the boxer needed only to assume a typical fighter's pose to round off the effect of strength and masculinity.

Canon EOS 10D, 28–70mm lens at 47mm, 1/60 sec at f/8, ISO 100.

Control light fall-off

Whether you are using daylight or studio flash to light your subject, being able to create and manipulate light fall-off is a good way of controlling where the main emphasis of the image is focused. With the lightest parts of the frame naturally drawing the eye, by determining where shadows fall it is possible to isolate the subject from the background and lead the eye to a particular point. With daylight, the easiest way to do this is to bathe the subject in directional light and then, using opaque light shields (large black polyester or cardboard sheets are most popular), to block out the light path to certain areas. This creates a strong contrast between lit areas of the subject and deep shadow. These types of light shield can also be used with studio flash. Alternatively, the flash heads can be fitted with attachments (such as barn doors or honeycombs) designed to control the direction of light.

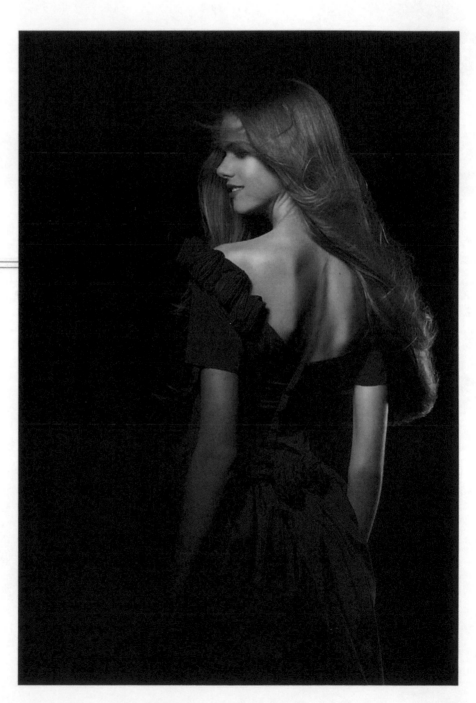

ISOBEL

This image was taken using two studio flash heads with the direction of light carefully controlled so that the emphasis fell on the subject's hair, face, shoulder and upper back. The light was also controlled to reveal the beautiful texture and colour of the dress, while ensuring this did not distract from the main emphasis. Two flash heads with honeycomb attachments were used. The main light was placed at 45° up and to the left of the camera so as to direct light on the face and upper torso. The second light was placed to the right of the camera at 120°. It acted as an accent light, which provided a less intense light to accentuate the body's shape as well as providing a rimlight to the hair and right arm. A black paper backdrop ensured that no light was reflected back on to the scene.
Canon EOS-10D, 28–70mm f/2.8 lens, 1/125 sec at f/11, ISO 100.

From tasteful nudes to sassy glamour images, the beauty portrait is a popular genre with both amateur and professional photographers. Here, we highlight the most popular styles and techniques used by modern photographers.

Beauty and Glamour

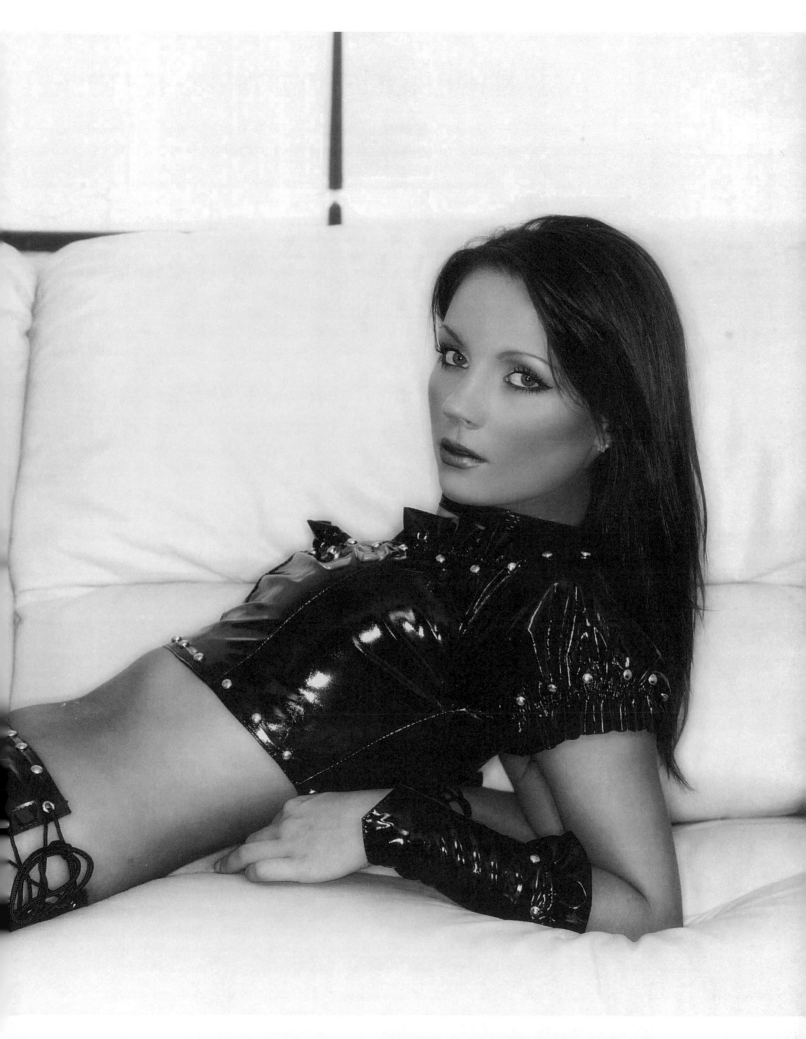

64 Ask the model to strike a pose

The pose that your subject adopts is central to the success of fashion and glamour shots, which often require a sense of confidence and dynamism. Experienced professional models have an extensive repertoire of poses and expressions and will normally adopt what they feel is best with little or no guidance from the photographer. However, with inexperienced models, the onus is on the photographer to give as much guidance as possible. Often, the best way to do this is through tear-sheets – basically pages torn from fashion and lifestyle magazines, illustrating poses similar to those that you would like the model to try.

Try as many poses as possible and be as imaginative as you can. Remember that this can be tiring work for the model, so regular breaks will increase the probability of success.

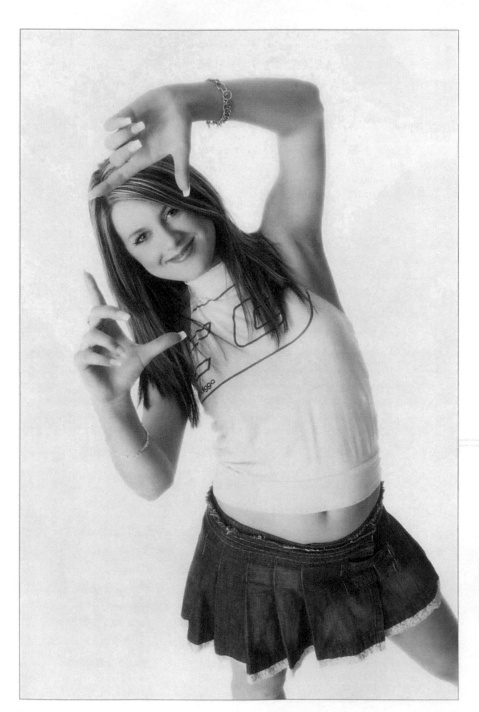

KAYLEE

The unusual pose adopted by this model instantly catches the eye. The position of her hands frames her face and helps fix the viewer's attention. The dynamic diagonal, created in part by the photographer tilting the camera and also by the model bending her body, adds energy to the frame. Also, getting in close and shooting from a slightly higher position adds a little distortion and results in the upper part of the body being slightly disproportionate to the legs.
Canon EOS 10D, 28–70mm lens at 28mm, 1/125 sec at f/8, ISO 100.

Take modern fashion shots

No area of portraiture changes its styles as fast as fashion photography. As quickly as a type of fashion comes and goes, the approach used to capture the clothes on camera changes radically too. Staying in touch with what's in and what's out is very important if you want to be considered a contemporary photographer. The trend in fashion photography recently has been one of understatement, where the fashion product is only subtly alluded to and the portrait is much more about creating a mood or feeling, perhaps conveying how the model feels about the item of clothing or how it reflects a certain kind of lifestyle. It becomes almost a challenge to decode the picture: were it not for a brand name or advertising copy, it would not be clear what it is promoting. This is a subtle approach to advertising, but the fashion world is filled with these types of images. It is worth giving it a try, as carrying it out successfully is quite a challenge.

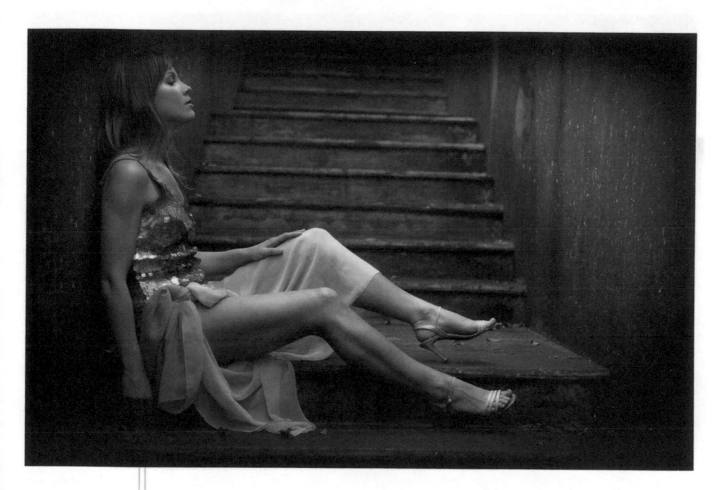

NELL AND SHOES

What is this image trying to sell? At first glance, it's not obvious, but gradually the purpose becomes clearer – it's the shoes. The photographer skilfully draws your eyes towards them. The model is looking away to purposely de-emphasize her face. Pulling the skirt away to reveal her leg draws in your eye, which is in turn led by the leg towards the feet. And should your eyes fall on the backdrop, the stairs lead down to a natural end at the feet. The left leg is purposely the brightest area of the frame, which makes it the main focal point, while the position of the left shoe ensures it is clearly in view. It is all very subtle and subliminal, but very effective. Welcome to modern fashion photography . . .

Canon EOS-1DS, 28–70mm lens at 60mm, 1/60 sec at f/2.8, ISO 400.

66 Shoot nudes in daylight

The secret to any great portrait is not only how you pose a subject but how you light them, and this is particularly true with nudes, where the fall of light and shade on the human form is the principal interest. Although studio lighting offers the ultimate in control, it is also possible to photograph striking nude portraits in daylight by following a few simple steps. The first is that you need to keep total control over where the light falls on your subject's body. You should do this by using diffusers, reflectors and black material (for controlling shadows). A diffuser should be used when light is harsh; a reflector to fill in unwanted areas of shadow; and black material to eliminate stray light and to help control shadows. With careful use of these three lighting tools, creating stunning nude shots is relatively simple.

DAYLIGHT NUDE

This image was taken in the middle of the day using only daylight as the light source. A sofa with black velvet draped over it was placed under a medium-sized window with netting to diffuse the light. The model lay on the velvet and rotated her body slightly to accentuate contours and form. She applied oil to her skin to make it more reflective and to increase the tonal range of the image. The photographer ensured the highlights were perfectly positioned on her body and, using black velvet angled towards the model just out of shot below the camera, prevented unwanted light reflections from filling in shadows.
Canon EOS 10D, 28–70mm lens at 70mm, 1/60 sec at f/4, ISO 400.

Shoot with studio flash

Using a studio flash set-up gives you total control of lighting. As well as being able to control the strength and direction of light, you can also control its quality, which means that you can make it as soft or as hard as you want. A softbox is ideal: use it with a white diffuser in place and you can create a soft, matte application of light; remove it to reveal the inner silver panels and you have a crisper, sharper effect with far more contrast. Once you have created the perfect balance, adjusting the power allows you full control of depth of field, as your working aperture is determined by the flash output. This versatility means you can play with form, shape, line and tone at will, like a painter arranging shapes on a canvas.

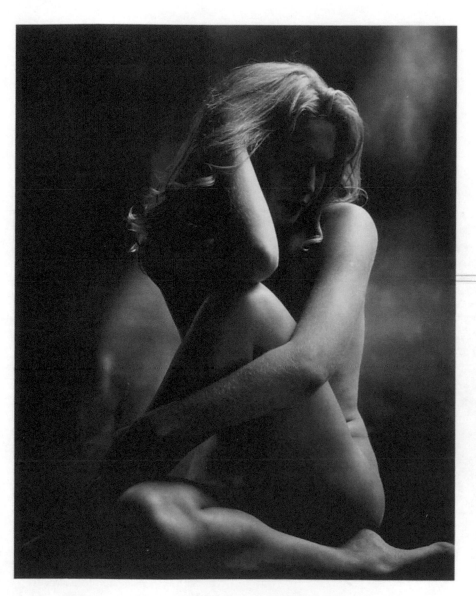

SHAPE AND FORM

Two lights were used for this shot, although only one illuminated the subject – this was a softbox, which bathed the model in soft light. The second light, with a barndoor attachment, aimed controlled, directional light into tin foil, which reflected on to a mottled cloth backdrop to give dappled reflections. The subtle lighting has allowed the photographer to accentuate shape and form, while tastefully concealing details and casting the subject's face in shadow. This has the effect of depersonalizing the image and placing emphasis on the model's shape and form. The final image was converted to monochrome and given a sepia tone.

Canon EOS-1DS, 28–70mm f/2.8 lens, 1/125 sec at f/8, ISO 100.

68 Add sex appeal

Whether you find sexuality in images distasteful or agreeable, there is no denying that it is one of the more saleable qualities of a photograph and one that will never go out of fashion. It is important to distinguish between images that suggest sexuality in a tasteful manner and those that are overtly sexual or even pornographic. Often, the images with the strongest sex appeal are the least explicit: exciting the viewer's imagination is the most powerful tool at your disposal. Therefore, aim to create allure in playful and provocative poses, expressions and clothing rather than using gratuitously revealing images.

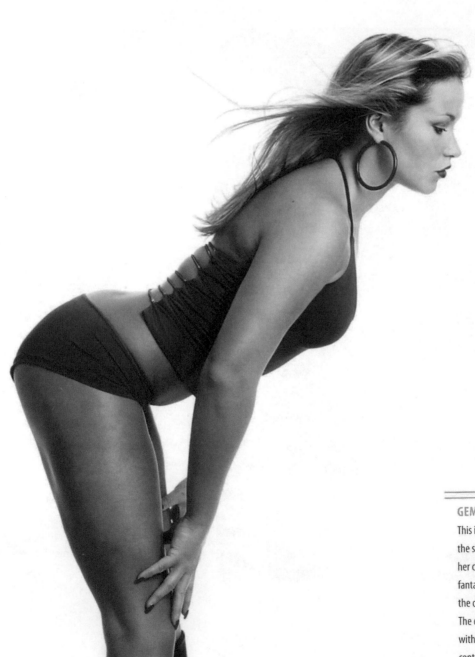

GEMMA

This image has bags of sex appeal even though the subject is fully dressed; her pose illustrates her curvaceous shape, and her natural beauty and fantastic figure are shown to good effect, the cut of the clothing drawing attention to what it conceals. The choice of a bright red outfit, accessorized with matching lipstick, earrings and fingernails, contributes to a strong, bold and sexy image. Canon EOS 10D, 28–70mm lens at 55mm, 1/125 sec at f/11, ISO 100.

Keep your nudes tasteful

There is a distinction in photography between 'nude' and 'naked', although the line may sometimes seem blurred. The latter suggests blatant exhibition of the undressed body, whereas a nude suggests subtlety and privacy. A successful nude portrait uses lighting and posture to capture the shape and form of the subject. Although the full figure may be revealed, more often than not private areas are concealed by body and limb position and careful use of lighting. In addition, the identity of the nude is often concealed, as it is not important to the success of the image. The key to the shot is to produce a graceful or interesting image where the human body forms a virtual landscape of curves and shapes. Skilled use of lighting, whether through natural lighting or studio flash, is vital to achieving the perfect result. By controlling the play of highlights and shadows on the body, it is possible to include the entire human body in the frame while keeping the image tasteful and the subject's modesty intact.

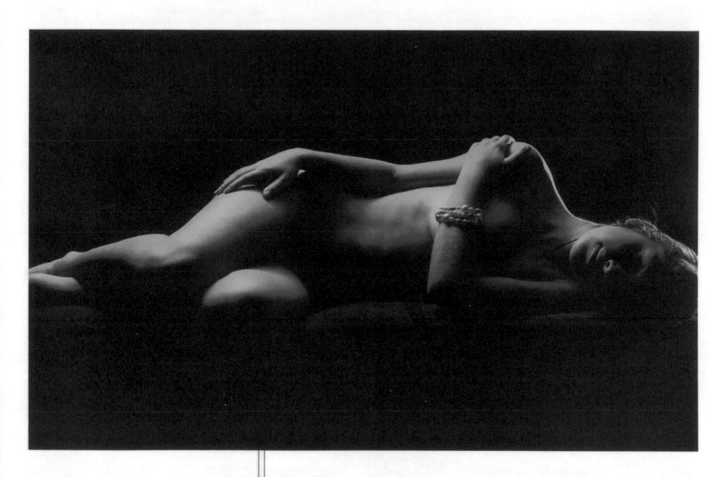

CONCEALED

Although entirely 'naked' and facing the camera, this nude nevertheless remains tasteful and protects the model's modesty. The photographer achieved this in three ways. First, the model's face was cast in shadow. Second, placing an arm across her torso meant that her breasts were not exposed. Third, the lighting was positioned so that areas of the body in highlight or shadow were carefully controlled. A strip light above and behind the model allows control of the figure's contours and shadows, while a second, harder light was aimed at the shoulder to add a dimension of depth to the image.

Canon EOS-1DS, 17–40mm f/4 lens, 1/125 sec at f/8, ISO 100.

70 Shoot a modern glamour image

Glamour photography, like other forms of portrait photography, shows trends, styles and fashions that change to reflect current fads and tastes. As much as with the clothes and hairstyles, the poses, look and attitude of the models are constantly changing. Since the massive growth of men's lifestyle magazines, glamour photography has become far more mainstream than it used to be. Shooting glamour no longer requires partly undressed or naked subjects – sexy and provocative poses are equally suitable. Find a willing subject and give it a try – there's no reason why it should not be fun for everyone involved.

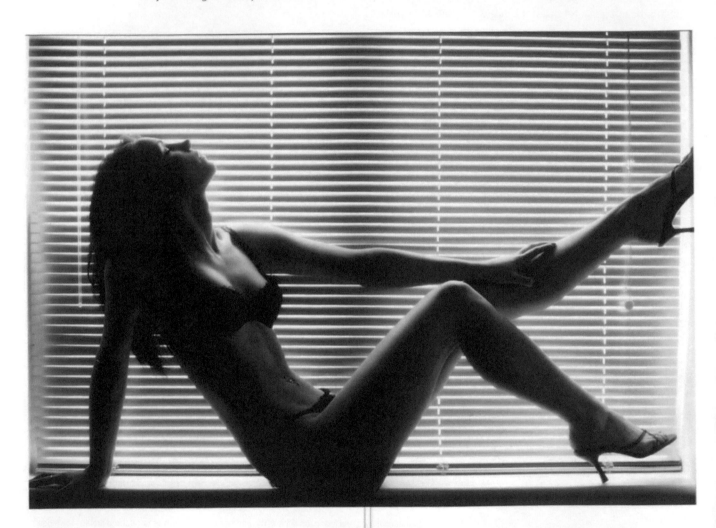

CHARLOTTE

Just to prove how the humble home can be used as a location for shooting great pictures, this shot was taken with the model perched on the sill of a kitchen window. The venetian blind slats were left slightly open to allow some diffused light through to create a very graphic backdrop, while a studio flash behind the camera provided very soft fill to reveal detail on the subject's body. Compositionally, this image works well through the use of triangles, which are a powerful visual aid and are created here by the positions of the arms and legs.

Canon EOS-1DS, 28–70mm f/2.8 lens at 50mm, 1/180 sec at f/8, ISO 200.

Perfect make-up and styling

Not even supermodels have perfect complexions all the time, so the application of make-up and styling can make or break a portrait. While the colour and style of make-up will vary according to the subject and the type of picture being taken, you should always try to ensure a smooth gradation of skin tones, as this makes for a far more pleasing and photogenic result. Although Photoshop can be used at a later stage to smooth tones further, the better the make-up before taking the picture, the less post-production work is required later. Many female subjects are adept at applying their own make-up, but for important shoots or when photographing men, a specialist make-up artist may be required. An application of foundation is the minimum you should use, while concealer under the eyes to cover up dark patches and mascara to emphasize the eyes are worth considering.

The other area to pay particular attention to is hair styling. Again, the actual style will vary, but you should ensure that hair is never messy – even windswept hair should be tidied up as much as possible.

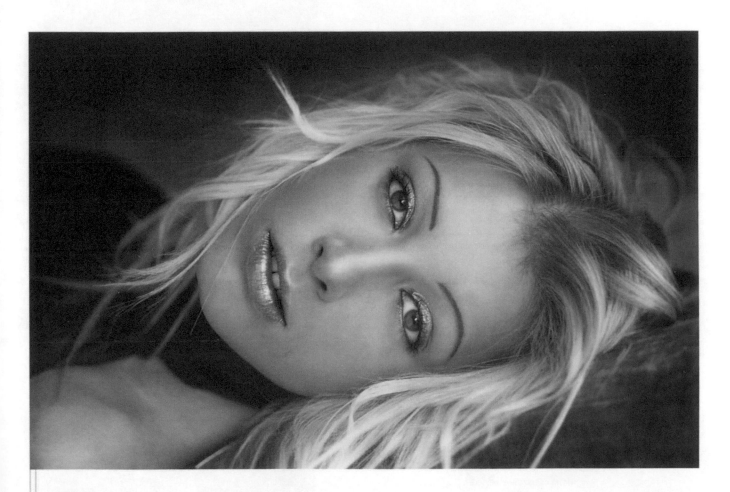

PERFECT STYLE

While the natural beauty and clear complexion of this model made taking a good portrait that much easier, it is the application of make-up and hair styling that really adds impact. Mascara and glitter around the eyes reinforce strong eye contact to grab the viewer's attention, while the shiny lip gloss adds another point of interest. The hair has been carefully styled to give a wild, windswept look without appearing untidy. A silver reflector was used to emphasize the skin. Along with the make-up style and hair coordination, this results in a very modern-looking portrait. Canon EOS-1DS, 70–200mm f/2.8 lens, 1/80 sec at f/2.8, ISO 400.

72 Control texture

Beauty and glamour photography tend to present a super-real picture of the world, featuring beautiful models with perfect skin in exotic or luxurious settings and wearing beautiful clothes. Texture can play a key role in creating this atmosphere, whether it is the porcelain smoothness of a model's skin, the sheen of silk or satin, the luxury of deep-coloured velvet or the brash kinky glamour of leather or PVC. The lighting techniques needed to make the most of textured surfaces will vary depending on the material in question. Shiny material requires lighting placed at an angle to prevent bright highlights and hotspots, while soft light is best for revealing the texture of furry or rough material.

FOYER FASHION

A luxurious settee was the perfect prop to shoot a full-length portrait for this model's portfolio. It's an example of a very simple set-up offering the potential for a powerful picture. The settee was located in a hotel foyer close to a large bay window, which bathed it in bright sunlight. A large diffuser was used to soften the light and smooth the model's complexion, while a reflector low at 45° brought out the texture of the sofa below her arm, as well as revealing the texture in the hair hanging down either side of her face.

Canon EOS-1DS, 70–200mm f/2.8 lens at 100mm, 1/100 sec at f/4, ISO 400.

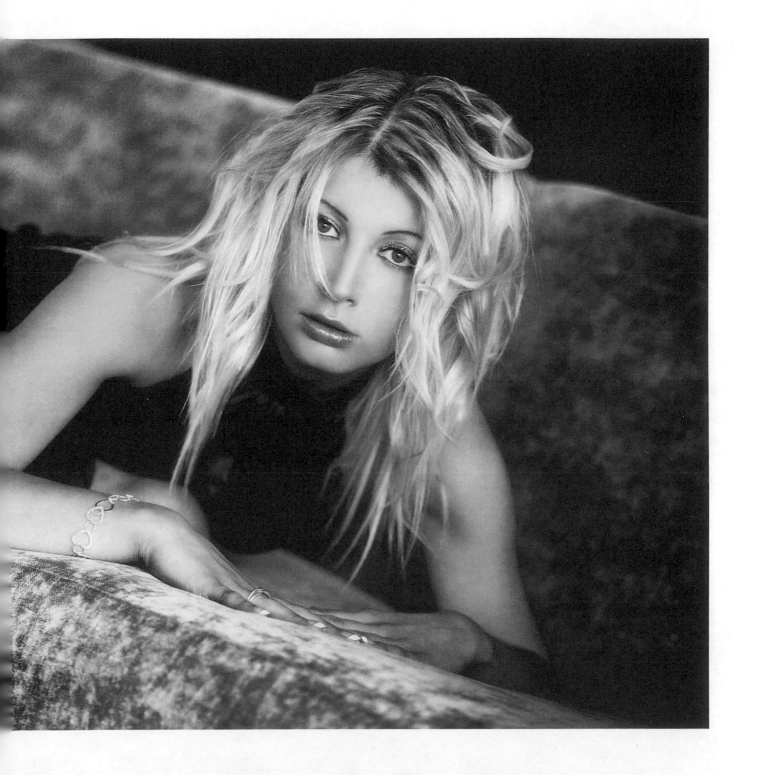

Family and Social

The social scene is a very important
and lucrative area of photography and
offers the potential to capture endearing
portraits. Your sensitivity to the subject
is as important as your photographic
technique in mastering this area.

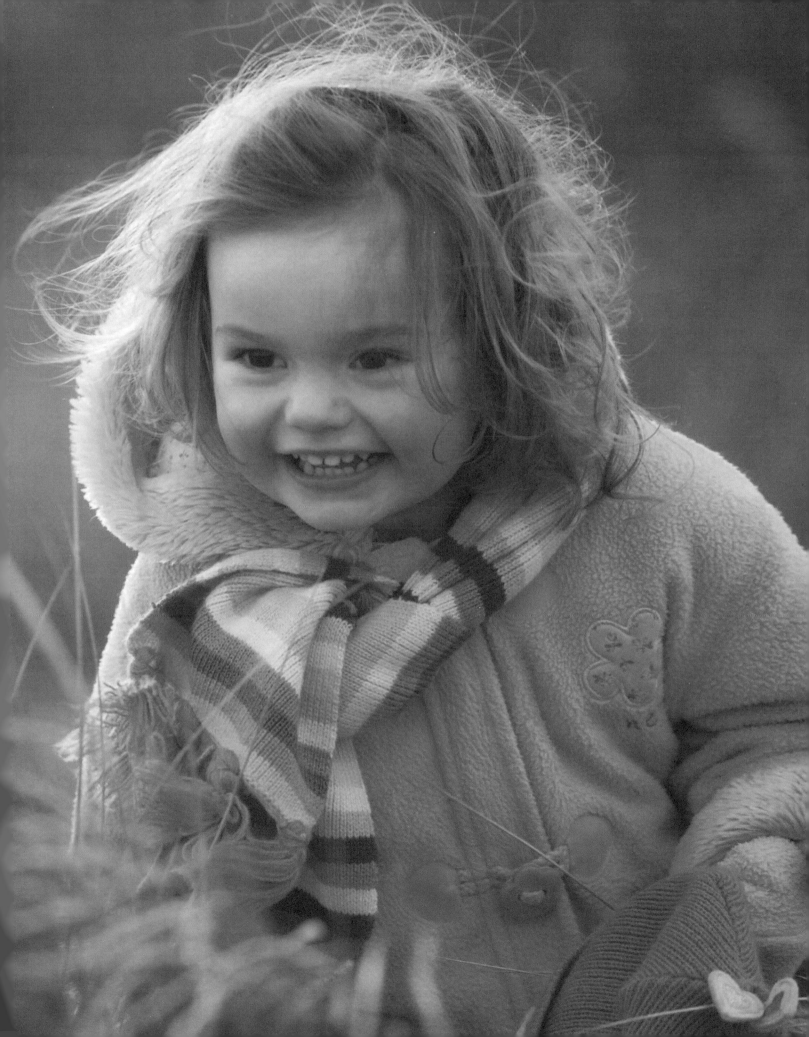

73 Capture a private moment

There is a fine line between invasion of privacy and capturing a private moment: people who are going through their normal routines and are unaware that they are being photographed could justifiably claim invasion of privacy if you take their picture. Candid photography of subjects who are in a situation where having their picture taken is quite likely is a more legitimate way in which to capture a private moment. A wedding or any other event where photographers are hired to work is a perfect example. The key is to be able to take pictures with your subject unaware that they are being photographed; this usually necessitates a long telephoto lens. If you are lucky, these images can be the most poignant and intimate form of portraiture.

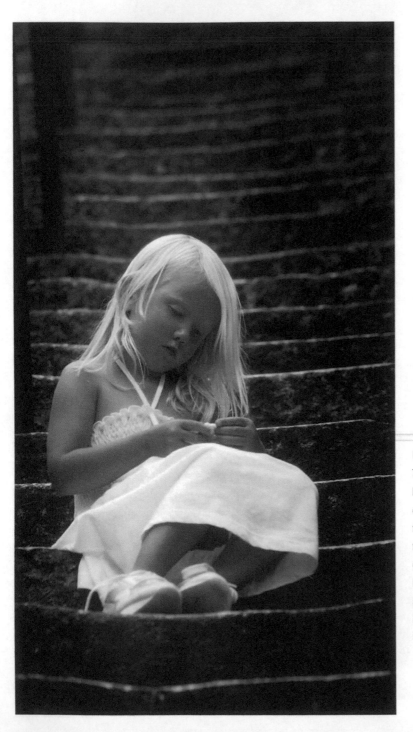

REBECCA

This special moment was captured seconds before the young girl looked up and spotted the photographer. Her thoughtful and serene expression is key to the success of the image; her attention was fully focused on the lace in her hand, which gave the photographer enough time to capture the shot. Her position on the stairs gives the image a good sense of depth, while a shallow depth of field ensures the steps in the background are not distracting. The light is soft and flattering. A white wall to the girl's right gently reflects light back on to her right cheek, which would otherwise be a little dark.

Canon EOS-1DS, 70–200mm f/2.8 lens, 1/160 sec at f/5.6, ISO 200.

Work with groups of children

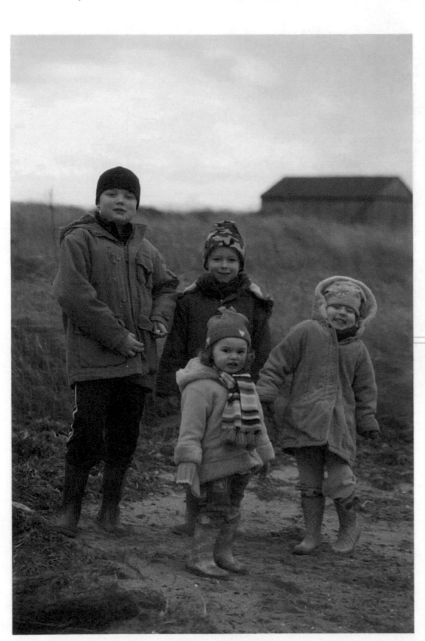

The phrase 'Never work with animals or children' was coined with good reason. Although one child can sometimes be difficult, a group of children tend to multiply the problems, with the antics of one child causing the others to play up. Some adults are able to handle these situations better than others; if you have a natural affinity with children, you could find this branch of photography is right for you.

If your group is particularly boisterous, don't try to force them to stop playing and pay attention. Instead, join in the fun for a few minutes and gain their trust. Then make taking their picture another game by challenging them to pose. Children are naturally competitive and are sure to want to be the best.

When arranging group shots, try not to be formal and formulaic with the poses. If all the children are standing up, it makes sense to have the tallest at the back, but having a couple sitting or kneeling, looking natural and resting against each other, always works well.

The best group photos of children are those that reveal their personalities, so don't restrict them by being too firm with your demands. Allow them to be themselves and this will be reflected in effective images.

WINTER WALK

Four young children, aged from two to nine, are captured on a winter's walk on the beach. The image works because they are arranged neatly, from the tallest on the left to the shortest on the right, with the youngest child at the front and in the middle. But this was achieved informally, so the children are relaxed and have not been instructed to take up rigid positions. This has resulted in a nice mixture of expressions on the children's faces.
Canon EOS-1DS MkII, 70–200mm lens at 110mm, 1/250 sec at f/4, ISO 160.

75 Put your subjects at ease

The success of some aspects of social photography relies heavily on emotions, particularly love and romance. When photographing couples you can be technically and artistically sound but if your subjects are tense and awkward you will not be able to get a convincing portrait. This is not a technique you can learn in the same way as lighting or focusing, but one that most of us have intuitively. It is your interpersonal skills and your ability to communicate with your subjects that come to the fore here. You need to make people trust you and go along with your ideas. Only if they are comfortable with you will they be relaxed enough with each other for their emotions to be expressed through your portrait.

TOGETHER FOREVER

This image was one in a commissioned series of social portraits and was taken in a style that is currently very saleable, with the subjects set against a pure white background so they have total prominence in the frame. As with any posed picture of this kind, a good amount of time was spent before the picture was taken, chatting to the couple and making them feel relaxed. Once in front of the camera, they were positioned so that they rested against each other and were posed comfortably. Their casual pose, with their heads leaning towards each other, gives a sense of unity and of a strong bond between them. A large softbox to one side of the camera and a reflector to the other provided a diffused, balanced light, while two lights were used to keep the background pure white.
Canon EOS-1DS, 28–70mm f/2.8 lens at 50mm, 1/125 sec at f/11, ISO 100.

Shoot an annual 'marker'

As any parent will tell you, children grow up very quickly. And because life is so hectic for so many people, weeks if not months can go by without you taking a portrait of your child. Many people address this by shooting annual 'markers'. These are portraits taken of the same person on the same day of each year. By doing this, families ensure they have up-to-date images as well as a visual record of how much development a child shows after a certain period of time.

The most common days to shoot markers on are those that mean the most to the photographer and his or her family. This may be Christmas, the subject's birthday, or that of a parent. The secret is to choose a day on which you will always remember to take the picture.

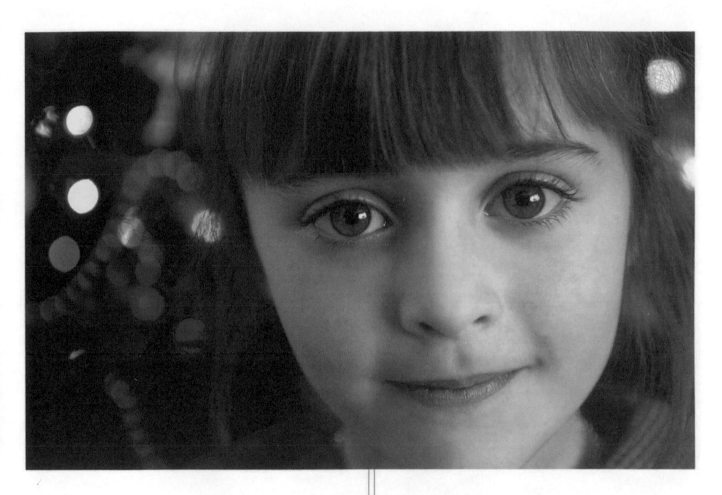

EMMA

This portrait of five-year-old Emma is the fifth to be taken on Christmas day. Her parents decided that this, along with her birthday, were memorable 'markers' and so each year on these days she has her picture taken by the Christmas tree or with her birthday presents.

Nikon D200, 18–55mm lens at 55mm, 1/20 sec at f/2.8, ISO 200.

77 Take grab shots of children

While there are times when a well set-up portrait session, with intricate backdrops and studied lighting arrangements, is required, there is no doubt that some of the most pleasing portraits of children are those that are captured without any such preparation. While these special moments are fleeting, there are some simple steps that you can take to ensure that, if such a moment arrives, you are ready to capture it. The first is an obvious one – you should always have your camera ready. Your camera should always be loaded with a film or memory card and the batteries should be charged. Also, while the camera will no doubt be switched off, you should have it set up so that it is ready for instant use. The best mode to set is aperture priority, with the aperture set to the maximum setting. This means that if you need the camera in a hurry, you can switch it on and know the aperture/shutter speed combination is ideal for a handheld exposure using only ambient light. This is important, as flash will detract from the natural effect. If you are shooting digitally, leave the camera set to ISO 400 to help keep shutter speeds high enough for handholdable exposures. The other factor to bear in mind if you are using an SLR is the type of lens you have attached to the camera. The best options are a standard zoom (e.g., 28–80mm) or a short telephoto zoom (e.g., 70–200mm); these are ideal for filling the frame with the subject while working at relatively close distances.

ALFIE

There was no preparation for photographing this toddler sitting happily on a sofa. The setting was ideal – diffused windowlight provided perfect sidelighting that revealed the child's hair and beautiful complexion. The neutral colour of the throw over the sofa does not distract and the child's expression is completely natural – he was unaware of the photographer, who was ready with a DSLR and standard zoom.
Canon EOS-1DS MkII, 70–200mm lens at 135mm, 1/40 sec at f/5.6, ISO 1250.

Capture childhood moments 78

Children grow up very quickly and it is important to be ready to capture their special moments on camera. The attitudes and expressions that seem so much part of their character can quickly change. Often a child may take up an activity for a short time before giving it up and, with the passage of time, you are likely to forget it unless you have a photograph to remind you. This could be the child's first ballet lesson, a special day on the beach, or their first kick of a football. Whether you carefully set up an image or take a candid shot, make sure you don't miss out on the special moments in your child's life.

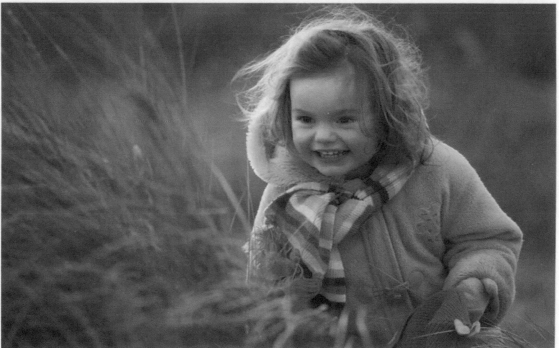

HIDE AND SEEK

Some children love to play up for the camera, while others are more camera-shy. Either way, you will often find that the best time to photograph children is when they are distracted and unaware that they are having their picture taken. The best time is when they are playing games – in this instance, hide and seek. Completely focused on hiding behind this outcrop of reeds, this young girl was oblivious to having her picture taken and so looks completely natural. Once she had been found, her happy dance also lent itself to being captured on camera.

Canon EOS-1DS Mark II, 70–200mm f/4 lens, 1/640 sec at f/4, ISO 320.

79 Choose a romantic location

Photographing couples, particularly for weddings, is a key part of social photography, and for many people their wedding is one of the only occasions in their lives when formal portraits will be taken. A romantic setting is obviously appropriate for such portraits and can contribute tremendously to their success or failure. There are a number of picturesque locations that have an inherent association with romance, including churches, castles, beaches and ornate gardens. The weather can also play its part, but don't be disappointed if it's not a perfect day; storms, mist, fog or heavy cloud can lend an evocative, romantic mood to a picture.

The secret to success is for the picture to go beyond the couple and the location and to tell a romantic story in a wider context. With this in mind, always be on the lookout for suitable backdrops and settings, whether they are historic buildings, atmospheric ruins or photogenic stretches of landscape. Make sure you take the couple there beforehand to check that they like it – your idea of an idyllically romantic location may be very different from theirs.

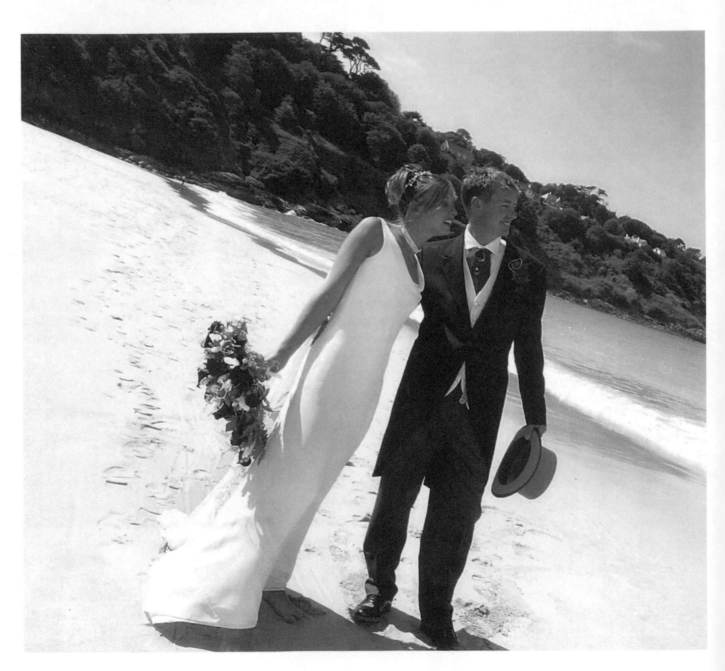

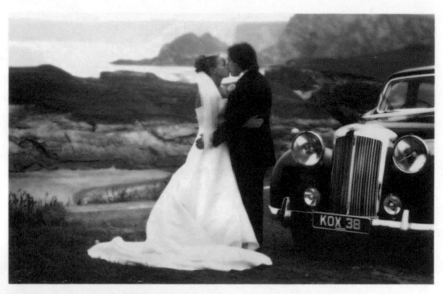

ROMANTIC LOCATIONS

Both these images use the location to create a strong romantic feel, each with its own distinct interpretation. The moody black and white image imparts a nostalgic feeling, with the vintage car, rugged coastline and softly diffused misty light. The colour image also conveys romance but with a more modern and vibrant feel, as the beach suggests an exotic Caribbean atmosphere.

Canon EOS 10D, 16–35mm lens at 16mm, 1/250 sec at f/16, ISO 400.

80 Show family ties

As well as capturing the personality of the subject in a portrait, it is important for a photographer to consider broader themes and the way an image can be used to interpret them. Showing a subject's relationship to other people can add much significant information to a portrait.

One of the most effective ways to illustrate this theme is to include several generations of one family within one photograph. Doing this not only illustrates the family hierarchy, but also depicts the strong ties that each generation has with the next and the love and trust that binds and protects all the individuals within that family group.

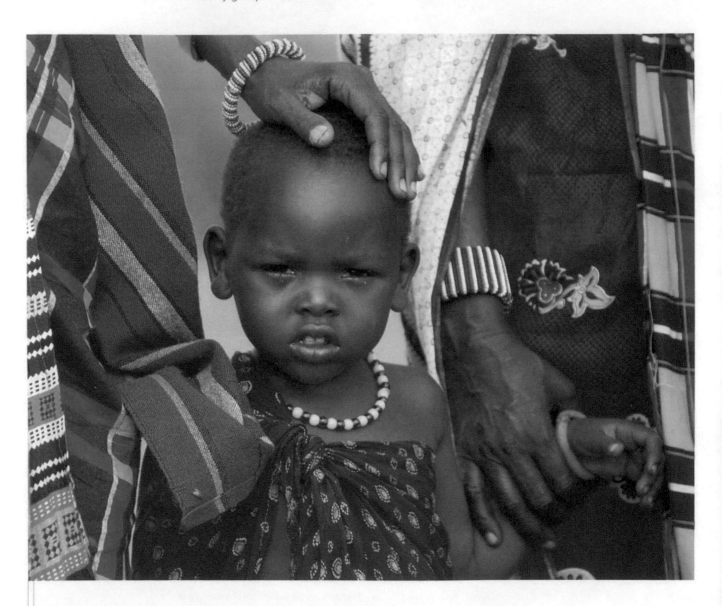

FAMILY
There is a strong sense of family connections in this simple image of a Masai child with two adults. Although we cannot see the adults' faces, it seems likely that they are the mother and grandmother of the child. The composition is particularly strong because of the connections implied by the triangle formed by the child's face, the hand on the child's head and the grandmother's hand.
Canon EOS-1DS MkII, 28–300mm lens at 260mm, 1/125 sec at f/5.6, ISO 250.

Capture key moments

Some of the most treasured personal images are those that may not necessarily be technically the best pictures, but that capture a special moment in someone's life or convey a special personal meaning. It is important that you include some visual clues within the image so that the occasion is obvious on viewing the picture. These clues can be as blatant as a birthday banner or celebration cake or can be as subtle as a ring being slipped on to a finger.

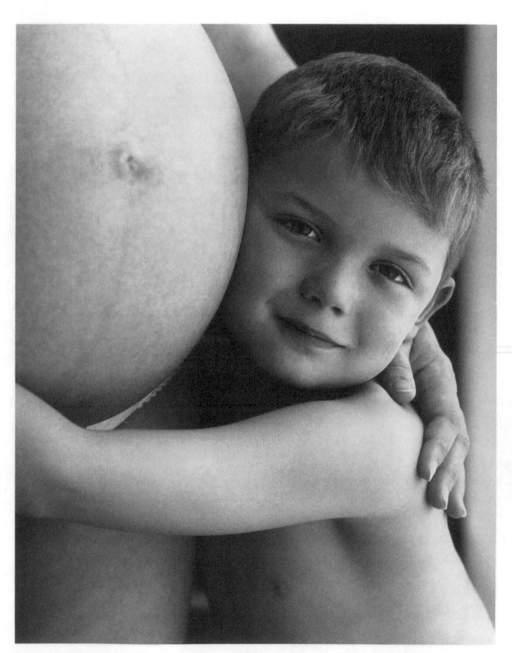

SIBLING

The imminent arrival of a little brother or sister obviously meant a lot to this boy. The shot was kept as simple as possible, as the photographer wanted all the attention to be centred on the contented expression of the child. The mother and boy were positioned by a window for natural, diffused light and the scene composed carefully so that the mother's 'bump' and the child's head dominated the frame. The boy's arm positioned across the frame forms a natural lead-in line.
Canon EOS 3, 28–70mm at 60mm, 1/125 sec at f/2.8, ISO 400.

82 Coordinate subjects' clothing

If it is within your control, it can be effective when shooting groups of people to ask each of them to wear outfits that complement and support each other aesthetically. If not, you run the risk of one member of the group's clothing clashing with the others, possibly making someone stand out or visually isolating them from the composition. Choosing complementary outfits creates harmony, adds to the balance and can help create a feel-good mood for the shot. Of course, it is not necessary to choose exactly matching outfits, but rather select colours, tones and styles that work well together.

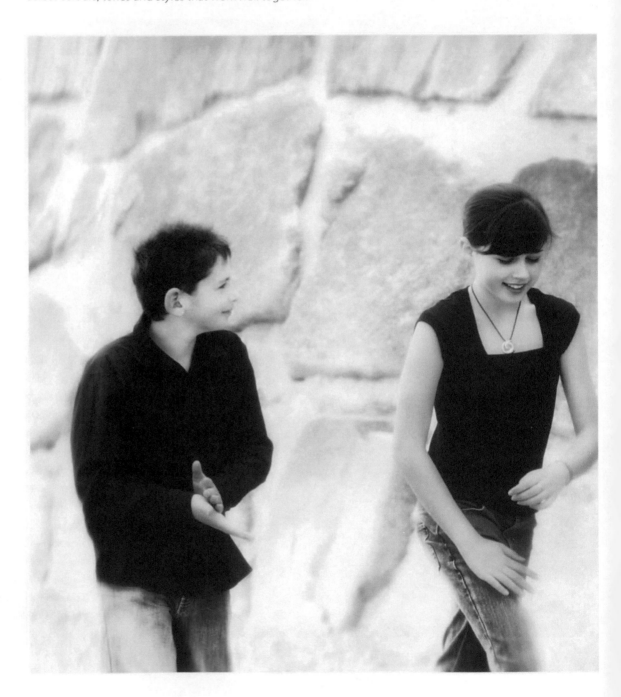

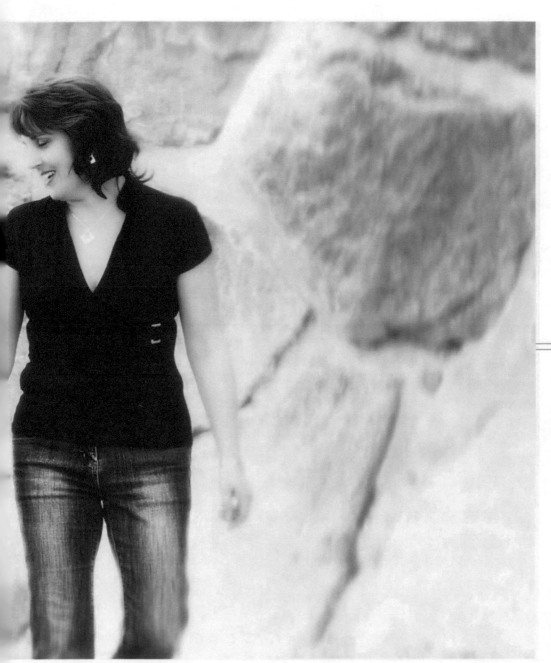

FAMILY WALK

The matching styles and colours of the clothing create a unity between these subjects. We can see the connection between the three people, not only because of their clothing, but because of their relaxed and happy expressions. The implied line that runs from the mother through to the son suggests a strong family bond. The lighting further adds to the relaxed and harmonious mood of the image: diffused through soft cloud and reflected by the light beach pebbles, it gives the scene a beautifully soft feel. Canon EOS 10D, 70–200mm lens at 70mm, 1/750 sec at f/3.5, ISO 200.

Creative Portraiture

Developing an individual style is an important step for any photographer. Whether you are shooting documentary images, travel portraits or fine art, pushing yourself to try new ideas and create your own style will help your photographic development.

83 Shoot underwater fun

A decade or so ago, shooting good-quality pictures underwater was the reserve of those who could afford specialist cameras, designed for this environment, or expensive underwater housings. In recent years, a number of soft camera cases have become available that can be used to depths of about two metres (six feet) – more than enough for snorkellers or for use in swimming pools. The emergence of digital compacts has also seen affordable hard cases that allow use to even greater depths, opening up the chance to take pictures that were not possible before. With so many low-cost options available, it is worth investing in one and shooting some underwater portraits. While the image quality will depend on the clarity of the water, depth and light levels, you should be able to capture some interesting results. When shooting in shallow water, the flash can be useful in bringing out strong colours of nearby objects, but it is best to set a high ISO rating and rely on available light.

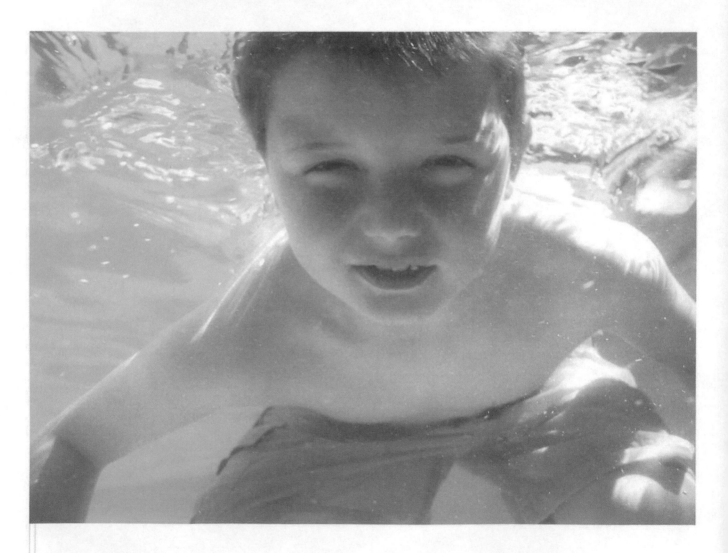

Because light behaves so differently when it travels through water, the results you can capture when shooting underwater are unpredictable and unusual. This shot was taken in an outdoor swimming pool using a digital compact in a specialist housing. The chlorine in the water and the colour of the pool's tiles result in a strong blue cast that dominates the image. While bubbles and debris in the water are picked up in the areas receiving direct light, general image quality is good, considering the modest cost of the equipment used.

Pentax Optio S40 in Pentax underwater housing.

Take effective travel portraits

Rather than well-worn views and famous landmarks, portraits can be a most effective way of revealing a location's true culture. When you are photographing a person in a foreign location, think about why you are actually taking their picture. What has attracted you to the subject? Concentrate on this aspect of the person. If you are in a hot climate and are capturing an elderly person with interesting, craggy and sun-beaten skin, try using a telephoto lens and close in on the texture of their face. If, on the other hand, you are in a market and you see someone who is selling exotic items, aim to include their stall in the photograph too, as this provides necessary context and says much about who the person is. Above all, you must show your subject respect: ask permission first, do not overstay your welcome and, if they are displeased about you taking their picture, apologize immediately and move on.

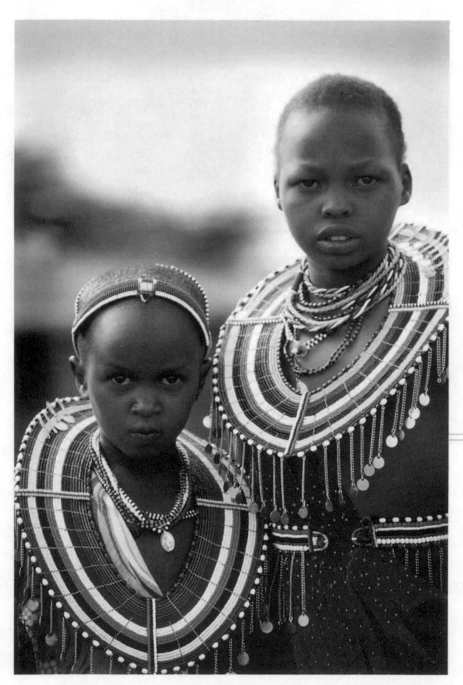

MASAI

The elaborate and colourful necklaces of these two Masai children help to express their identity. A telephoto zoom ensures that the frame is filled with the pair, while a wide aperture throws the background out of focus. Although this is a very simple composition, the photographer has been very alert and adopted a low viewpoint in line with the smaller child to give the portrait maximum impact.

Canon EOS-1DS MkII, 28–300mm at 300mm, 1/640 sec at f/5.6, ISO 400.

85 Shoot a fine-art image

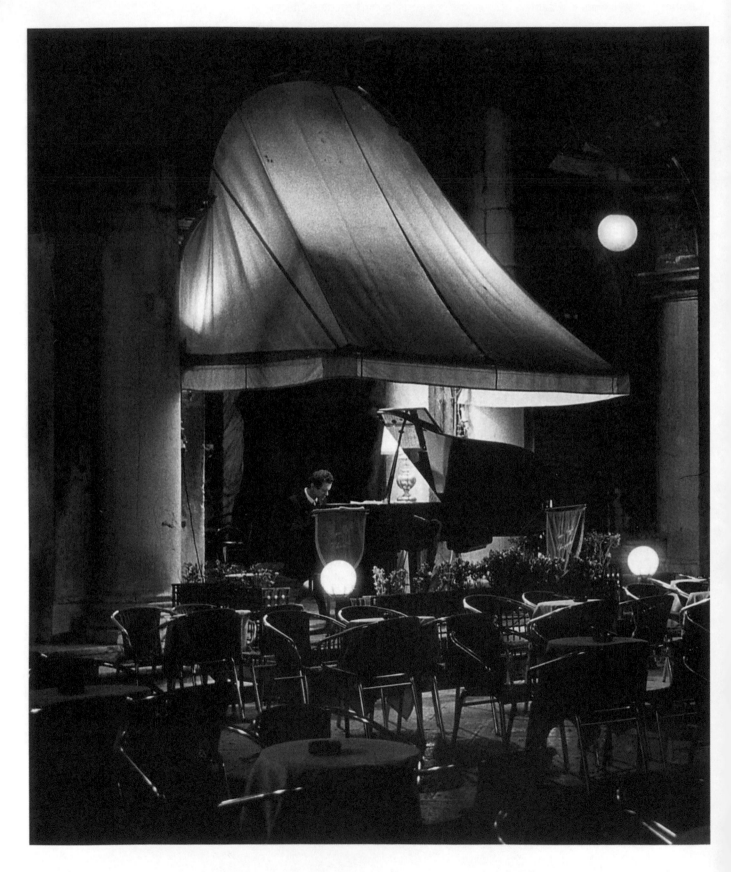

What separates a fine-art image from any other form of portrait? There are no strict rules that define what a fine-art image is or how it differs from other types of portraits, but there are some guidelines to help you create distinctive and saleable images. Possibly the most crucial factor is deciding whether to shoot in colour or black and white. While both media are suitable, the timeless quality of black and white and the feeling that monochrome images are a departure from reality often give it an edge over colour.

Many fine-art portraits play down the role of the subject, as the power of the image comes from the pose, the lighting and the general photographic style. The ambiguity or universality of such an image can give it a classic look and build its fine-art appeal. Another successful approach is to choose a composition that tells a story, in particular picturing a subject in the environment of their home or workplace. These images often gain appeal over time, as the clothing and locations gather charm and historic significance as the years pass by.

PIANO MAN

A pianist plays a lonely melody in St Mark's Square in Venice. This beautiful moment typifies the qualities that make a successful fine-art portrait: its timeless nature, its strong sense of mood and the unidentifiable subject at the heart of the image. The low light demanded that the camera rested on a stable surface while the scene was exposed for the shadows to retain as much detail as possible. This image won the BIPP's International Fine Art Photograph of the Year 2003.
Canon EOS 3, 28–70mm f/2.8 lens, 1/30 sec at f/3.5, Fuji Neopan 1600, ISO 800.

86 Shoot from the hip for candid portraits

Looking through a viewfinder is usually a basic requirement for taking a good photograph, but that is not to say that you can't try shooting from the hip when the need arises to take images discreetly. This form of candid photography has gained increasing popularity with the advent of digital photography, and the reason is simple: without looking, the image you are capturing is hard to predict and there is a high probability of failure. With film this would be a costly affair, but shooting digitally means that you can take as many shots as you like to maximize your chances of capturing a successful one.

Either hold the camera with one hand down at your side or hang it from a strap over your shoulder and control it with one hand from there. Remember to check that the lens, if a zoom, is set to a wide enough angle to capture the environment around your subject. Also ensure you are firing with a fast enough shutter speed to avoid camera shake and that the flash is switched off, as this will give the game away!

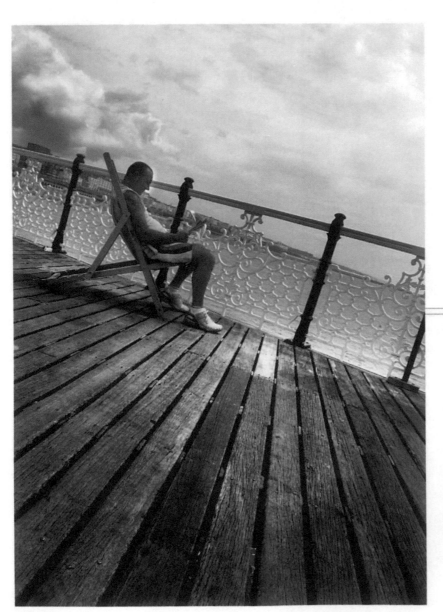

DECKED OUT

This candid photograph was captured on Brighton Pier on the south coast of England. While it appears that the man sitting in the deckchair is some distance away, he was in fact quite close; the accentuated perspective is due to the focal length used – the lens was a 17–40mm zoom set to the wide-angle end. What works here is that the boards of the pier act as a natural line for the eye to follow, while the railings also help lead the eye to the subject. The jaunty angle also suits the image.

Canon EOS 10D, 17–40mm at 17mm, 1/400 sec at f/8, ISO 100.

Get creative with the human form

A portrait does not necessarily have to involve a 'likeness' of the subject, it may be that other parts of their body, or even other objects, can tell us something useful about them. Once freed from the constraint of including a face, the human body offers tremendous opportunities to create interesting and creative, even abstract, images using careful framing and lighting.

The secret to creating this type of image is the lighting. Only by very careful control of where the highlights and shadows fall is it possible to create such illusions and abstracts. It can be done with daylight, but the time required to achieve the perfect lighting means studio flash is a far better choice.

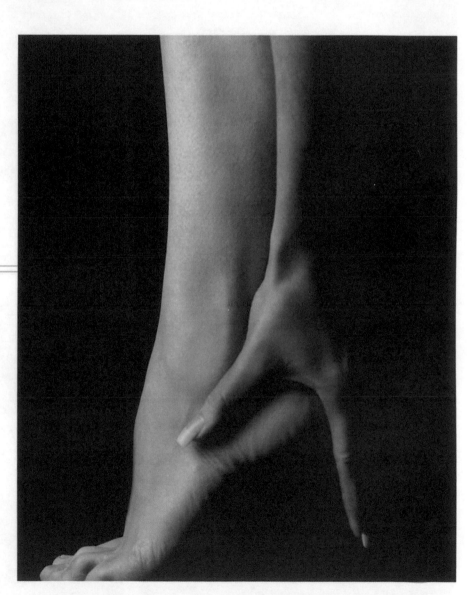

STILETTO

A step beyond portraiture, although this could be an interesting portrait of a shoe designer or someone with a passion for shoes. In this instance, the subject has arched her foot and placed her hand along the back of her leg to emulate the heel of a stiletto, while her thumb creates the impression of a strap. This image is not an original concept but was inspired by a similar image seen in a book. While original ideas are preferable, do not be put off trying to recreate an image you have seen, as you will learn much from trying to reproduce the original. This image was taken in a studio using a single softbox positioned at 90º to the camera, with the subject positioned on a black velvet backdrop.
Canon EOS-1DS, 70–200mm f/2.8 lens, 1/60 sec at f/6.3, ISO 100.

88 Shoot environmental portraits

The subject is the focus of any portrait, but everything else in the frame can give information to support an interpretation of who they are. Environmental portraits seek to reveal a subject's personality and something of their life, usually by setting them in their workplace or home. Far from being just picturesque, this is what tells us about the subject beyond their physical characteristics. In more controlled circumstances you can make sure that your composition includes objects or even activities that directly relate to the subject and help the viewer build up a picture of their life and personality.

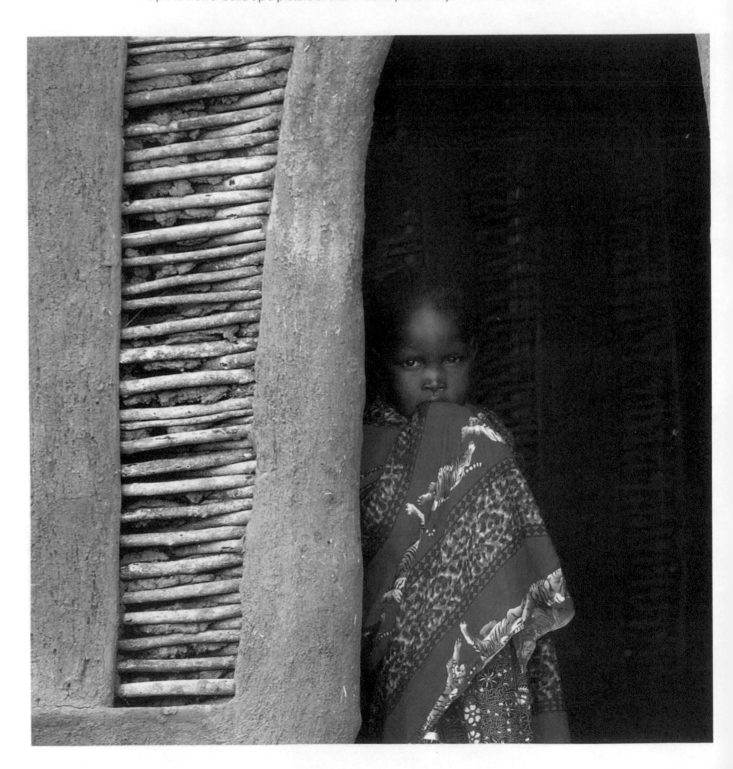

HOME ALONE

This child was photographed unawares. The photographer noted the boy wandering in and out of the hut and how well the child stood out against the dark interior. Preparing for the shot and firing the shutter as soon as the boy was in position created a relaxed informality to the image. Although in this case the environment is simply the walls of an African hut, this alone gives us a wealth of information and allows us to speculate about the boy's circumstances, giving us a glimpse into his life.

Canon EOS 350D, 70–200mm at 160mm, 1/200 sec at f/4, ISO 400.

89 Construct a narrative

We have discussed a number of ways in which it is possible to reveal aspects of your subject's personality or manipulate the setting to control the atmosphere of a portrait. A logical next step from this approach is to tell a story in the picture. This may be a complete fiction or constructed to illustrate an aspect of your subject's life. The subject is unlikely to look at the camera in such a portrait, and the use of props and a 'real' situation will encourage the viewer to decode the image and imagine the story of the picture.

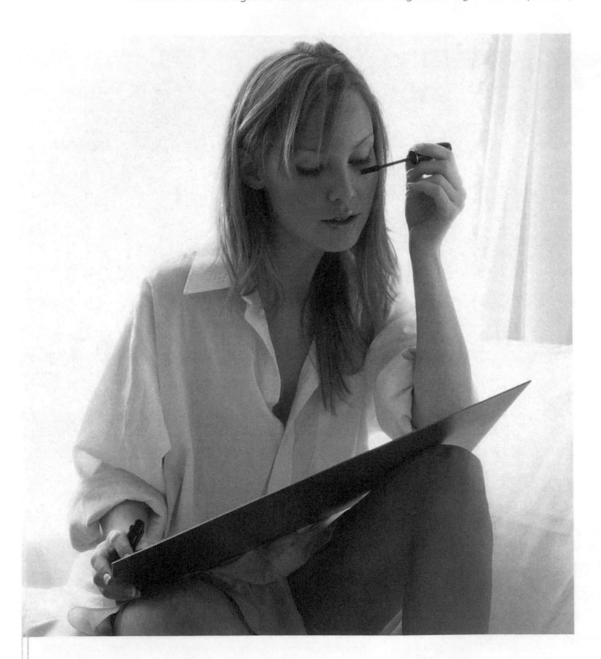

GETTING READY

This simple windowlit portrait shows a woman applying make-up. The fact that she seems unaware of our presence makes the situation feel natural and it is easy to imagine that it is early morning and she is getting ready to go out for the day. The mirror she holds has the extra benefit of throwing light back up on to her face. Canon EOS 10D, 28–70mm f/2.8 lens, 1/125 sec at f/2.8, ISO 100.

Shoot a reportage portrait

Photojournalists have given us some of the most powerful portraits in history, from the triumphant to the horrific and everything in between. Photographing people in real situations, as important events unfold, allows the photographer to capture them at moments of extreme emotion, passion, fear or anxiety, which is impossible to create artificially. Most people can't go chasing wars or natural disasters around the world, but it is possible to seek out events that are closer to home, such as demonstrations, sporting events or political gatherings, where emotions may run high and you can capture reportage portraits of people fully engaged in an activity and oblivious to the camera. A telephoto zoom of around 70–200mm or 70–300mm allows you to keep your distance yet capture frame-filling candid shots, while a superzoom such as an 18–200mm or 28–300mm opens up the possibility of wide-angle scene-setters too.

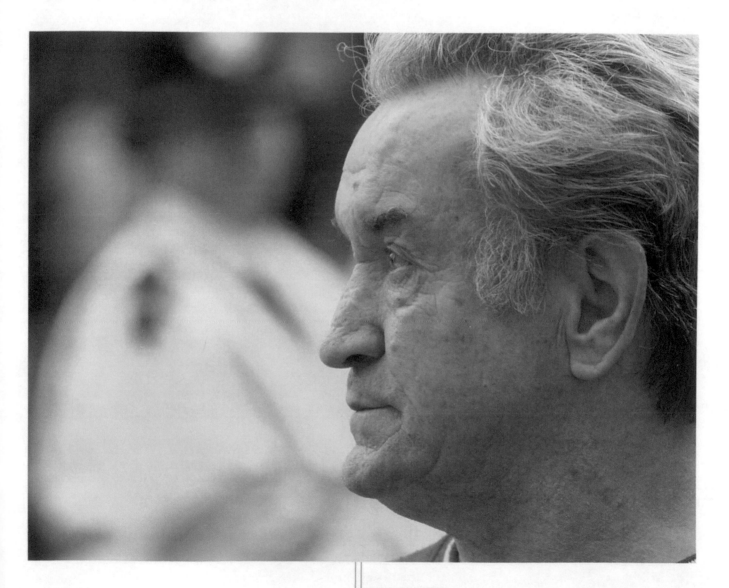

DEMONSTRATOR

Clever composition is the key to this image. The protestor's face dominates the right side of the frame and, although we can't see who he is looking at, the out-of-focus yellow jacket of a policeman in the background gives a clue. A telephoto zoom was used, and cropping tightened up the composition.

Canon EOS 20D, 70–200mm lens at 70mm, 1/320 sec at f/5, ISO 200.

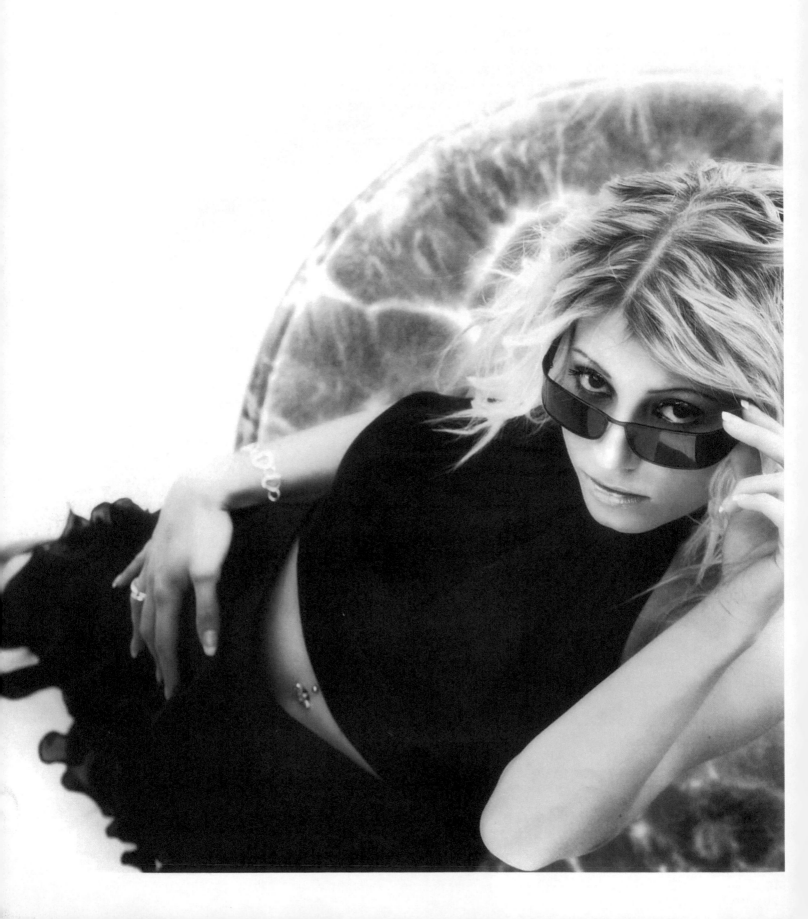

The development of image-
manipulation software – in particular
Adobe's Photoshop – has resulted in
post-production techniques becoming
an intrinsic stage in the formation
of the final portrait. From subtle
changes to radical alterations, digital
enhancements can add the final
touches to your portraits.

91 Clean up clutter

Software programs such as Photoshop are often termed image-manipulation packages, as they allow you to alter an image in any number of ways. One of the most common methods is to remove unwanted elements from an image. The Rubber Stamp, or Cloning tool, is the most popular way of doing this. It allows you to set a reference point and, when applied, clone this area elsewhere in the frame. With outdoor portraits, you will find the Cloning tool is an invaluable aid for removing distracting objects behind or to the side of the main subject, such as lampposts, trees, litter or bright highlights such as reflections. The Cloning tool must be used carefully so that cloned areas are not obvious, but with a little practice and patience you will find cleaning up clutter from your image can be quite a speedy process and will drastically improve the final image.

CLEAN GETAWAY

The jaunty angle of this image adds to the unusual combination of priest and sports car. As you can see by comparing the original with the final version, contrast has been boosted (using Curves) to lift the scene – particularly the car's metallic finish. Unfortunately, there were two cars in the background and one behind the priest: they were distracting and needed to be removed. Cropping the frame easily removed the car on the right, but careful use of the Cloning tool was required to eliminate the cars in the background. A further enhancement could have seen the car and priest placed in an entirely new background. Canon EOS 10D, 16–35mm lens, 1/125 sec at f/4, ISO 400.

Add Diffuse Glow

Diffuse Glow is a relatively little-known Photoshop tool that works particularly well when applied to high-key portraits. It is found by selecting Filter > Distort > Diffuse Glow and works automatically to attack the highlights and the lighter areas of the image. It is a particularly useful tool for portraits as it adds a softness to skin and smooths highlights. However, it should be used with care as light and dark areas can bleed into each other, which will ruin the overall effect.

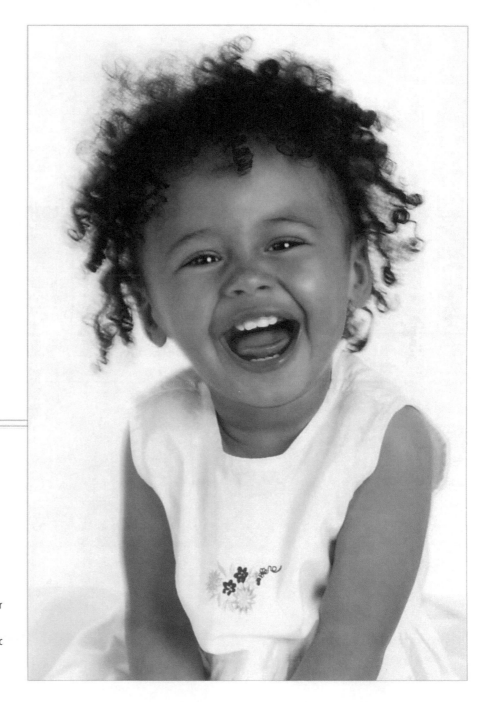

AALIYAH

This delightful portrait shows just what is possible with Diffuse Glow. This is a high-key portrait created by using flash to light the subject and deliberately overexposing the background with windowlight. The slow shutter speed also allowed a little subject movement to be captured, which adds to the mood of the shot. The Diffuse Glow has not only lightened the background, white top and flash highlights on the skin, but has also melded the area where the hair and background meet to good effect.
Canon EOS 10D, 70–200mm lens at 70mm, 1/750 sec at f/4, ISO 100.

93 Convert colour to black and white

Black and white photography holds a special magic that has ensured its popularity despite the arrival of colour film and, more recently, digital photography. The latter development has actually resulted in black and white photography being more popular than ever, with software programs such as Photoshop allowing photographers the chance to create stunning black and white images from their colour digital files. While darkroom printing required years of skill and training, as well as a dedicated room and many hours to produce a single image, the humble home inkjet printer makes monochrome prints easier than ever.

If you are using Photoshop, there are various methods for converting a colour image to black and white. The simplest is to choose the Desaturate command via the Image Adjustments menu. This produces a reasonable result most of the time, but there is a far better way to do it. Go to Image Adjustments and select Channel Mixer. Click the monochrome box to remove the colour and then play with the three colour sliders to create the result you want. The great thing is that you can experiment and, so long as you are working on a copy of the original file, you can make as many mistakes as you want and know you can always try again.

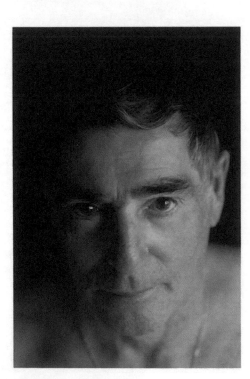

MONOCHROME

This portrait was taken with a view to it becoming a black and white image, but a similar technique can be used with almost any portrait. The subject was windowlit from the side to highlight one side of the face while putting the other side in deep shadow. By using the Crop, Levels and Channel Mixer commands, an average colour portrait was converted in less than five minutes into a striking monochrome photograph.

Canon EOS-1D MkII, 70–200mm lens at 100mm, 1/80 sec at f/2.8, ISO 100.

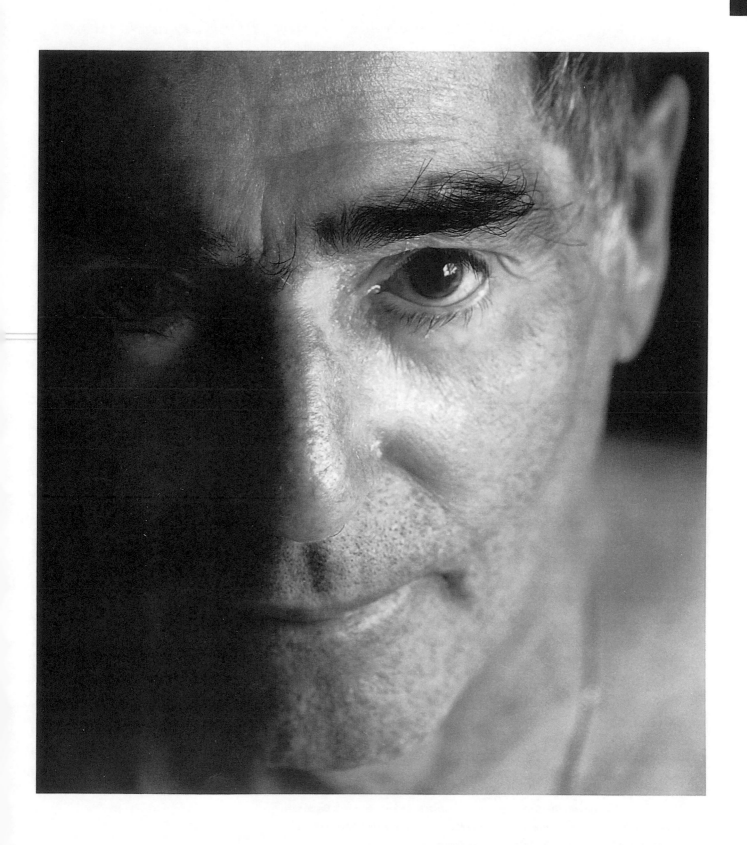

Digital Enhancement

94 Add grain for atmosphere

It is ironic that while film manufacturers have striven to minimize grain and digital camera makers develop sensors with reduced noise levels, there is a case for adding this effect to your images for creative reasons. While grain is often regarded as a negative side-effect of image capture, it can be used to add texture to an image and give it a sense of atmosphere. Whether its coarse, gritty nature appeals to you is purely subjective, but it is worth trying it out. You may even find it a useful alternative to cloning skin blemishes, as it is a good way to cover up small imperfections.

Noise can be added in Photoshop by selecting Filter > Noise > Add Noise. This brings up a window that allows you to vary the amount and distribution of noise (digital grain), as well as selecting whether the noise is colour or monochromatic in nature.

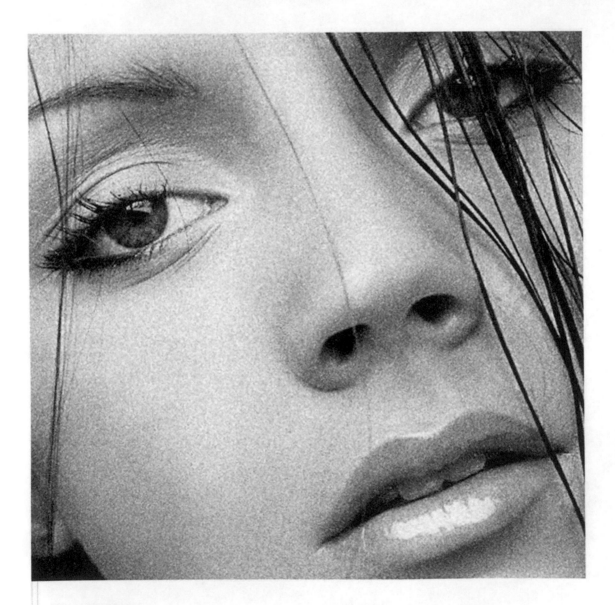

THE ART OF NOISE

This closely cropped portrait was quite effective before any grain was added, but was felt to be lacking in mood because the skin tones were too smooth and even. Adding colour noise in Photoshop brought an additional element to the image and led to this shot being used on the cover of a well-known magazine.

Canon EOS 10D, 28–70mm lens at 70mm, 1/8 sec at f/8, ISO 100.

Smooth skin tones

No matter how clear someone's complexion is, there will always be imperfections, such as wrinkles, spots, scars, blotches or moles. While this is perfectly natural, most subjects like to look their best, which is where Photoshop's Healing and Cloning tools can come to the rescue. These two tools offer the opportunity not only to remove blemishes, but to take the smoothing of skin to an almost unnatural level. While this can look unrealistic, from a commercial point of view it is appealing and certainly the way things are going with professional portraiture. The Cloning tool has long been the most popular choice for the job, allowing areas of smooth skin to be cloned over the imperfections. However, the development of the Healing tool, which allows the texture to be transposed while retaining the tonal representations, offers a powerful alternative. Both tools are selected from the toolbox and use a target point on the image to 'clone' over the imperfection.

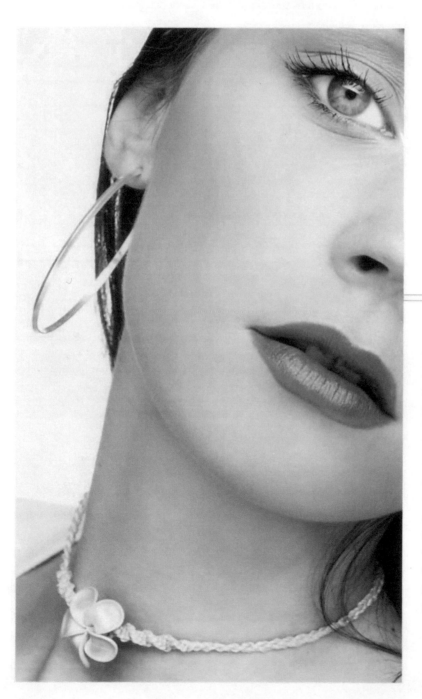

ANGEL

The aim of this portrait was to use the unusual crop to force the viewer's eye to investigate the various focal points of the portrait before settling on the subject's eye. The necklace, earring and lips each provide natural resting points for the viewer to fall on and, to help the eye's journey, the skin has been lightened and smoothed to create a clean and perfect texture. The Healing tool was used first of all to keep the tonal characteristics created by the make-up and lighting. Then the Cloning tool, set to an opacity of 25%, was used to smooth the skin even further. While the subject's complexion was excellent to begin with, these two tools ensured perfect skin tones and texture.
Canon EOS 10D, 28–70mm f/2.8 lens, 1/125 sec at f/16, ISO 100.

96 Try digital toning

Photoshop is renowned for the way it allows traditional darkroom skills to be recreated with greater ease and in far less time. One of the most popular of these techniques is the digital toning of monochrome images to add a subtle and uniform colour effect. While colours such as sepia and blue have traditionally been popular, Photoshop allows for these and an infinite number of other colour tones to be applied.

Not all monochrome images are suitable for toning, but you can experiment and delete any attempts you make that you don't like. Be aware that the denser the tone applied, the darker the image will become, so if you want to apply a heavy tone, lighten your monochrome image first.

There are two popular techniques. The first is to select Image > Adjustments > Variations and use the diagram to reach the tone you want. Alternatively, use Photoshop's Duotone function. First, convert the image to Grayscale (i.e., lose all colour information) by selecting Image > Mode > Desaturate. Then select Image > Mode > Duotone to reveal a window that allows you to select any colour tone you want. If you use the latter method, when you have finished, convert the image back to RGB colour (Image > Mode > RGB Color) before saving.

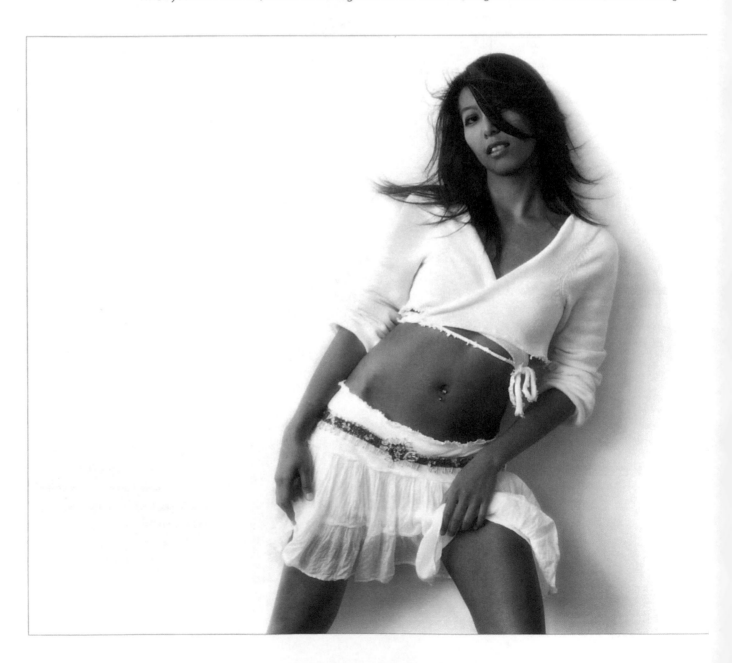

WELL TONED

The original untoned image (above) has been improved by the application of a subtle tone.

A light brown tone was applied using the Duotone process to give a pleasing toned effect.

Canon EOS-1DS, 28–70mm f/2.8 lens, 1/125 sec at f/6.3, ISO 100.

By selecting Variations, it is possible to click on various options to achieve the tone you want.

The Duotone method is a little more involved but allows for a greater choice as well as more consistency.

97 Add colour to your monochrome images

While toning and hand-colouring are traditional methods of adding a splash of colour to monochrome prints, Photoshop has offered an extra option. By converting a colour image to black and white, it is possible to retain colour in particular areas of the image where you want to create emphasis. There are two popular ways to do this in Photoshop. The first is to use a Lasso tool to select an area. Then, depending on whether you want to lose the colour from inside this area or outside it, the inverse command in the Select menu is selected. The alternative way is to create a duplicate layer and lose the colour information from it. Then, careful use of the Eraser tool brings the colour back in. A graphics tablet is recommended for accuracy when carrying out either of these methods.

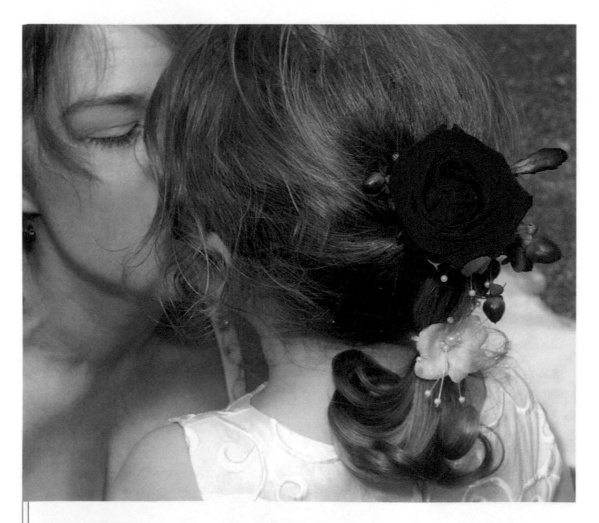

A SPLASH OF COLOUR

This image lacked a particular point of emphasis when completely monochrome because both faces are obscured, so there was no natural focal point. However, bringing the colour back into the rose makes a marked difference, with the dominant red grabbing the attention. The Lasso tool was used with a feather of 50 pixels to select the flower and inverse selected so that the colour information was retained inside the selection area and removed from the rest of the frame.

Canon EOS-1DS, 28–70mm lens, 1/250 sec at f/18, ISO 400.

Try a cross-processing effect

The technique of cross processing has long been popular with film photographers, in particular those shooting fashion portraits who are looking to create images with a distinct visual characteristic. The principle is fairly straightforward and involves deliberately processing film in the wrong chemistry. Slide film users put their films through the C-41 process to obtain negatives and prints, while print film users process their films in E-6 chemistry and end up with a set of slides. The results often show high contrast and unrealistic colours but are unpredictable and vary according to the brand and type of film used and the processing.

This technique can be easily simulated using the Curves function in Photoshop, which allows you to fine-tune the effect you want to achieve in a way that was never possible with film. By setting two anchors on the curve (at the upper and lower thirds of the curve), the contrast of the image can be carefully manipulated to create bright, high-contrast portraits.

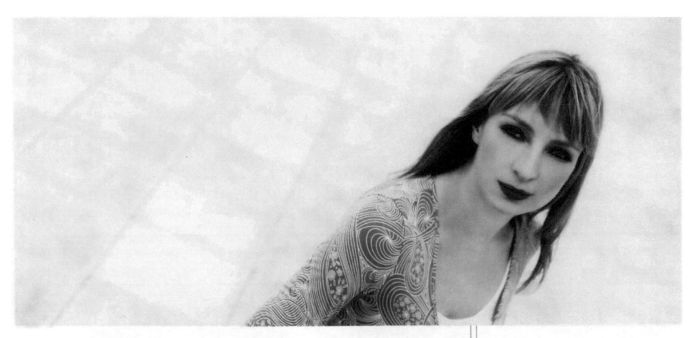

Select the curve by choosing Image > Adjustments > Curves from the pop-up menu. Create two anchors by clicking the cursor on the curve one-third of the way from the top and bottom.

By moving the anchors left or right or up and down, you can adjust the contrast and create a cross-processed result.

HOLLY

Although you can take an existing picture and apply the cross-processed effect to it, it is usually best to shoot with the aim of using this technique. For this fashion portrait, the model was asked to wear a patterned top and apply make-up to her lips and eyes, as the increase in contrast would accentuate these colours. The lighting was kept even and non-directional, as any shadows would block up and highlights burn out once the curve was manipulated. Finally, the subject was set against a light-coloured background that would bleach out in the final result. As is evident from the 'before' and 'after' images, the cross-processed effect has added considerably to the impact and interest.
Canon EOS-1DS, 28–70mm f/2.8 lens, 1/125 sec at f/4, ISO 100.

99 Create dark vignettes

One of the most popular techniques utilized by darkroom users to control the exposure on different parts of the print was that of dodging and burning. This technique has been incorporated into Photoshop, which features a Dodge tool for lightening areas of the frame and a Burn tool for darkening areas. This combination allows for subtle control of where the viewer looks, with the eye being led away from dark areas and towards light areas. Darkening the edges – in particular the corners – to draw the eye to the centre of the frame is known as vignetting, which can also occur by accident if too many filters are fitted to a lens or if the lens hood is incorrectly attached. As well as simply using the Burn tool to gradually darken areas, it is possible to create the effect by using the Lasso tool to define a selection and then adjusting the brightness to darken the corners. This technique has the advantage of retaining the tones of the selected area, whereas the Burn tool adds a grey tone.

KEVIN WITH SAMURAI SWORD

A wide-angle shot of this swordsman was required to include the samurai sword in the frame. This led to a large expanse of the background being visible, which, because of its light tone, draws the eye away from the figure. To get around this, a dark vignette was added to the corners of the frame so as to lead the eye back into the frame. The vignette was achieved using a Lasso tool to surround the fighter. Once the area was selected, choosing Select > Inverse ensured the corners were darkened rather than the area within the selection. A 200-pixel feather was selected to graduate the effect, and choosing Image > Adjust > Brightness brought up a sliding scale for control of the vignetting. Canon EOS-1DS, 28–70mm f/2.8 lens, 1/250 sec at f/9, ISO 100.

Use high-key vignetting

Vignetting is associated with dark corners caused when light reaching the lens is obscured by a filter or filter holder, and is often considered a problem. However, high-key vignetting has the opposite effect, lightening the corners so that the image appears to fade gradually as it reaches the edges of the frame. This is used quite commonly with wedding images and portraits to add a romantic look. It is also used where visual lines in the scene risk leading the eye out of the frame. The technique is the same as for a dark vignette: make a selection around the focus of the image with a feathered edge to graduate the effect and in Image > Adjust > Brightness move the slider up until the edges have burnt out.

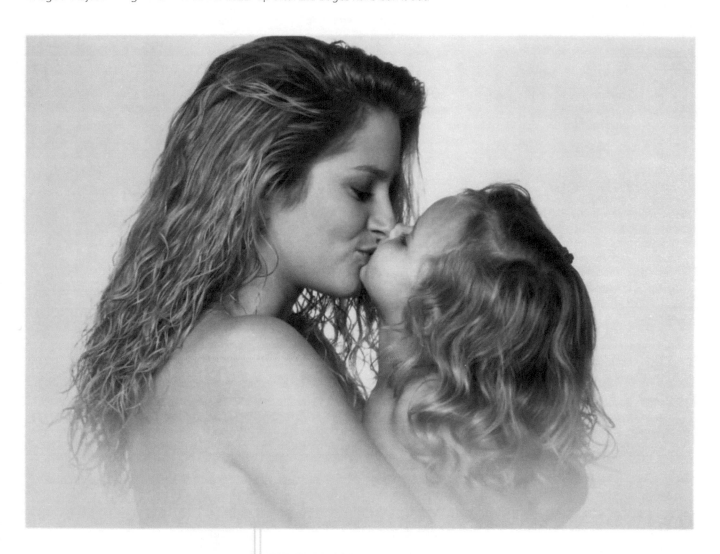

MOTHER AND CHILD

With this image, the photographer was aware that the lead-in line created by the mother's arm in the foreground could easily lead the viewer's eye out of the frame. By creating a high-key vignette, the eye is kept in the central area of the image and because the background is white, the effect looks natural. The scene is lit by soft flat lighting from two lights, with the main subjects lit by a large softbox. This is a very touching and intimate portrait that is made all the more enchanting because of its simplicity and the similarity between the mother's and daughter's hair and complexion. The vignette was achieved in the darkroom by moving a mask around the edge of the frame so that the print received far less exposure and so appeared lighter around the edges. A similar efffect is achievable very easily in Photoshop.

Canon EOS 5, 28–70mm lens, 1/125 sec at f/4, Kodak TMax 100 film.